ART IN *f*OCUS

LONDON

Thomas Parsons

A Bulfinch Press Book
Little, Brown and Company
Boston • New York • Toronto • London

Contents

London has an enormous amount of art in a bewildering variety of places, ranging from huge national collections such as the Victoria and Albert Museum to eccentric gems such as Sir John Soane's Museum. Even a life-long resident of the city would have difficulty in finding the time to explore all of them thoroughly. This book, written with the visitor in mind, does not try to be comprehensive; instead it is selective and personal, presenting around a hundred places or objects. These include museums as a whole and buildings of architectural importance as well as individual paintings, sculptures or other artefacts. This introduction places the individual entries that follow in a briefly sketched historical context, discussing broad patterns in patronage and collecting.

By way of introduction, two fundamental points should be kept in mind. The first is that London today has grown from two separate cities: the City of London to the east (often known simply as as the City) and the city of Westminster to the west. The City, on the site of the original Roman settlement, was (and remains) the centre of commerce and finance (1). Westminster, on the other hand, was the site of London's first royal palace. Until the two merged towards the beginning of the eighteenth century they existed as rival and distinct centres – the one royal, the other mercantile. The important thing to bear in mind here is that until they joined, the business of art (that is, its production and consumption) in London lay almost exclusively in the hands of the monarchy and the court.

The second introductory point concerns the Great Fire of 1666. It was the City of London, not Westminster, that went up in flames that September night more or less destroying all the old medieval buildings. But as the City was rebuilt, and its western perimeter spilled outwards to converge with the eastern edges of Westminster, so political power was

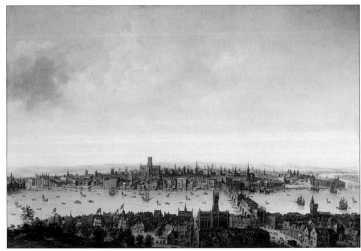

1. THOMAS WYCK, *LONDON FROM SOUTHWARK*, 17TH CENTURY (MUSEUM OF LONDON)

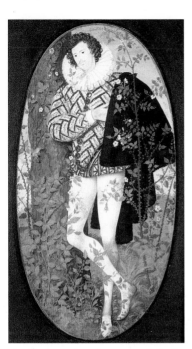

simultaneously taken out of the hands of the monarchy and given to Parliament. This double transformation (physical and political) had far-reaching consequences on art. Patronage and collecting were no longer a royal or courtly prerogative but became important and respected occupations for the aristocracy and, eventually, the bourgeois classes.

Westminster's pre-eminence dates from the eleventh century, when the English king, Edward the Confessor, decided to enlarge the Benedictine abbey there and build his principal royal palace close by (page 123). The first Westminster Abbey was Romanesque in style; the second, which replaced it in the thirteenth century, was Gothic. Both buildings borrowed heavily from French architecture. In other respects, with a few notable exceptions, art produced for the English court up to the seventeenth century remained to a large extent resistant to continental developments (see the *Portrait of Elizabeth I* in the National Portrait Gallery, page 79; *The Cholmondely Sisters* in the Tate Gallery, page 95; and the portrait of Anne Cecil at Ranger's House, page 84). The enjoyment of decorative pattern and delicate linear definition in Hilliard's miniatures, for example, which were produced largely for the court of Elizabeth I, would have appeared very old-fashioned to contemporaries in Italy or France (2).

Henry VIII's reputation is based more on his marital diversions and his engineering of the break with Roman Catholicism than on his artistic patronage. Nevertheless, in the early sixteenth century Henry opened up the English court to artistic influences from the continent by employing foreign artists of the calibre of Hans Holbein (see *The Ambassadors* in the National Gallery, page 65) and Pietro Torrigiano (Tomb of Henry VII in Westminster Abbey, page 123). Henry's daughter Elizabeth I was of less significance as a patron. However, her successor James I's patronage of the Italianate architect Inigo Jones early in the seventeenth century (see the

Banqueting House, page 19, and the Queen's House, Greenwich, page 76), heralded the reign of his son Charles I, during which English art was brought directly into contact with continental developments (3).

Charles viewed art collecting as an important part of a monarch's role. The ruler was to be measured by the splendour of his statues and paintings, in addition to the magnificence of his residences and retinue. Previously the Royal Collection had been made up predominantly of portraits celebrating dynastic rule, but Charles acquired works which he judged to be of independent artistic value, irrespective of their subject. Such attitudes had originated in Renaissance Italy. In emulating them Charles also offered an example to his court. In his own day the Duke of Buckingham and Lord Arundel had their respective collections to rival the King's. By the following century no English aristocrat's residence would be considered complete without a collection of European paintings.

The Great Fire broke out on 2 September 1666, seventeen years after Charles's death. Samuel Pepys recorded the sight in his diary a few days later: '… saw all the town burned, and a miserable sight of Paul's church, with all the roofs fallen, and the body of the quire fallen into St Faythe's;

CHARLES I AS PATRON OF THE ARTS

The painter Peter Paul Rubens described Charles I as 'The greatest amateur [that is, connoisseur] of painting among the princes of the world.' Charles, indeed, for all his weaknesses as a political ruler, was one of the greatest and most influential patrons and collectors in English history. From Rubens he commissioned the ceiling of the Banqueting House (4) among other works, but the artist with whom Charles is most closely associated is Anthony van Dyck, who spent most of the last ten years of his life (1632-42) in London as court painter. His portraits of Charles and his courtiers are so seductive that we tend to see this period of English history through his eyes. These portraits have had an immense influence on generations of subsequent English artists (pages 48, 66, 84). Charles also collected voraciously – miniatures, sculpture, coins and medals, and tapestries as well as paintings. These he displayed in the numerous royal palaces in and around London. His favourite pieces, including eleven paintings by Titian,

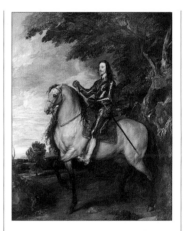

were kept in his private apartments in the old palace of Whitehall. The acquisition of great works of art was viewed at the time as a reflection of a king or prince's status. Or as the writer Ben Jonson expressed it, 'The most royall Princes and greatest persons [should] be studious of riches and magnificence in the outward celebration or shew.' Charles was blessed with a good eye – he collected pieces for their artistic value as much as to enhance his

Paul's school also, Ludgate and Fleet Street. My father's house, and the church, and a good part of the Temple and the like.' The tone is almost shocking in its sang-froid. For some, on the other hand, the fire was dramatic and conclusive evidence of God's judgement. For others it was proof of a Popish plot to destroy this Protestant city. But whether the fire was both or neither of these things, it certainly provided the newly restored monarchy, under Charles II, with the opportunity of rebuilding the city in more modern and far grander style. Sir Christopher Wren, Charles II's appointed architect, was not permitted to realize his most ambitious and grandiose plans. Architectural and financial caution prevented his scheme of building of a completely new complex of streets radiating from a series of squares and open spaces. He did however rebuild most of the City churches as well as the cathedral of St. Paul's, though he was obliged to stick to old foundations (6, 7). A French visitor recorded his impression of the new city in 1691: 'It is a matter of amazement to see how soon the English recovered themselves from so great a desolation, and a loss not to be computed. At three years end near upon ten thousand houses were raised up again from their ashes, with great improvements. And by that time

public standing. When, for example, he commissioned a portrait bust of himself he chose the Italian Bernini to sculpt it because what he wanted was not simply a convincing likeness but something from the hand of a great artist. The Bernini bust was unfortunately destroyed in a fire; and much of the rest of his collection has been dispersed. Following Charles's execution in 1649 the new Parliament found itself desperately short of cash and sold many of the pieces he had purchased. A fair number of these works now hang in the great museums of Paris, Vienna and Madrid, snapped up by foreign collectors who were amazed at how cheaply they were offered. However, some of the greatest works of art that can be seen in London today were brought here by Charles – for example, the Raphael cartoons in the Victoria and Albert Museum (page 112), which he bought while still Prince of Wales in 1623, and Mantegna's *Triumph of Caesar* at Hampton Court (page 42).

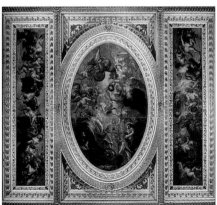

3 AND 4. (OPPOSITE PAGE) SIR ANTHONY VAN DYCK, *CHARLES I ON HORSEBACK*, c. 1638 (NATIONAL GALLERY); (LEFT) RUBENS, CENTRAL PANEL OF BANQUETING HOUSE CEILING, COMPLETED 1635

the fit of building grew so strong, that, besides a full and glorious restauration of a city that a raging fire had lately buried in its ashes, the suburbs have been increased to that degree, that (to speak modestly) as many more households have been added to it, with all the advantages that the able and skilfull builders could invent, both for conveniency and beauty.'

By law, all new building was to be in brick to avoid the risk of fire. London expanded enormously in the process. Most of the aristocratic palaces along the Strand were pulled down to provide space for housing and shops, thereby joining the City with Westminster. At the same time many of London's squares were laid out. Lincoln's Inn Fields and Covent Garden had been constructed before the Fire (see St. Paul's, Covent Garden, page 33), but these were soon followed by Bloomsbury and St. James's Squares at the end of the seventeenth century, and by Hanover, Berkeley and Grosvenor in the next. Together with the new St. Paul's Cathedral (page 89), now a conspicuously modern rival to Westminster Abbey, they utterly transformed the appearance of London. Visitors from abroad began to admire its architectural beauty. Certain writers compared its raising from the ashes to that of Troy – which also burned down to be reborn in a different place as Rome. London had become a new Rome, one of many European cities to claim that title. It was this new, spacious and ordered city that Canaletto came to paint, arriving in London in 1746. His views of the city are in many ways tributes to Wren, and in particular the City churches, than they are to any specific buildings.

London's expansion, westward as far as Park Lane and northward to just beyond Oxford Street, coincided with the beginnings of the British Empire. From the time of the Great Fire into the eighteenth century, the City too changed in character, becoming a financial rather than a mercantile centre and eager to fund entrepreneurial adventures overseas. Manufacturing dispersed to east and west, for example to the potteries established in Bow and Chelsea (see the *Group of Chinese Musicians* at the Victoria and Albert Museum, page 114). At around the same time, with the British constitution now weighted in favour of Parliament, the royal

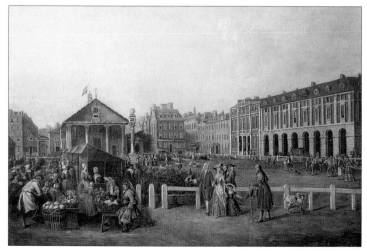

5. Balthasar Nebot, *Covent Garden with St. Paul's Church*, 18th century (Guildhall)

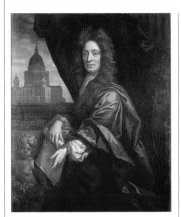

6. J.B. CLOSTERMAN, *SIR CHRISTOPHER WREN*, C. 1695 (PRIVATE COLLECTION)

Sir Christopher Wren (1632–1723) started his illustrious career as a mathematician and astronomer (one of the most brilliant of his day), but the Great Fire of London in 1666 gave him the opportunity to turn an amateur interest in architecture into his life's work. In 1669 Charles I appointed him Surveyor-General to the Crown. His brief was to implement two Acts of Parliament passed to effect the rebuilding of the City. And between 1670 and 1688 Wren was involved, apart from his work on St. Paul's Cathedral (page 89), in the rebuilding of fifty-one of the City's churches. (Many of these have had to be rebuilt once again following the fires of the 'Blitz' in the early 1940s.) The commission was a daunting one. The reconstruction had to be done quickly and cheaply. The churches were to be made predominantly of brick because stone was too expensive (a perennial problem as far as London's architecture is concerned since there are no quarries nearby). They also had to be built on the existing foundations – again, digging new ones would have cost too much.

Wren's challenge was manifold. As well as building within these practical and financial constraints, he was in addition faced with a large number of sites that presented similar, if not identical, ground plans. These in turn had to be transformed into architecturally different solutions. Furthermore, irregularities and quirks in these old medieval sites had to be disguised – for the prevailing style of architecture was classical, and therefore at root geometrical and symmetrical. When occasion demanded he showed that he could also design in other architectural styles – in a modified Gothic for instance at St. Dunstan-in-the-East, or in a Dutch style at St. Benet, Paul's Wharf, for example. As a whole then, the commission demanded a flexible and undogmatic approach. The spires of Wren's churches were generally built later, for spires are luxuries not necessities. They are among his finest achievements and Wren himself described them as 'an ornament to the town'. They defined the City's skyline until modern high-rise buildings arrived.

<div style="writing-mode: vertical">INTRODUCTION</div>

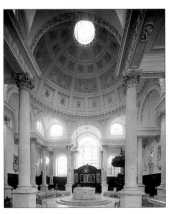

7. ST. STEPHEN'S WALBROOK, 1670S

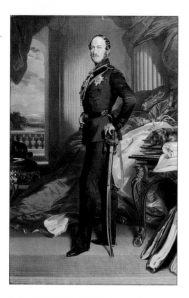

8. WINTERHALTER, *PRINCE ALBERT*, (LATER
REPLICA OF A PORTRAIT DATED 1859) (NPG)

9. EMBROIDERY DESIGNED FOR WILLIAM
MORRIS & CO., *c.* 1890 (V&A)

family moved from Westminster to Kensington Palace (page 46), possibly to remove themselves from under the gaze of the House of Commons.

But if for some London was a new Rome, for others it had become a new Sodom or Gomorrah – where the city's expansion had brought with it increased vice and moral degradation. A French traveller for example, writing in 1726, noted the number of brothels to be found in the area around Covent Garden (5): 'There are coffee-houses that serve as meeting-places for learned men and wits; some that are frequented by the dandies; others that are the haunts of professional newsmongers and political commentators; and many that are temples of Venus. You can easily recognize these last because they sometimes have signboards with a woman's arm or hand holding a coffee-pot. There are plenty of establishments of the kind in the Covent Garden area that pass as chocolate houses, where you are served by beautiful nymphs, very clean and neat, who seem most friendly but are exceedingly dangerous.'

It was this side of London life that Hogarth chose to illustrate in his paintings (see *A Rake's Progress* in Sir John Soane's Museum, page 91). These he also engraved and sold very successfully in print form, thereby making 'fine art' available to a much wider audience than before. There are a number of corollaries to these beginnings of bourgeois involvement in the business of art. The Royal Academy was founded in 1768 (page 85) and its annual exhibitions gave artists a chance to present their work to a larger and more diverse public without having to attract specific commissions first. George Stubbs (page 96) and Thomas Gainsborough, for example, produced pictures for both aristocratic and bourgeois markets (see *Mr and Mrs Andrews*, in the National Gallery, page 67; and *Mary, Countess Howe* at Kenwood House, page 48).

At the same time, following the precedent established by Charles I and using the wealth and prestige generated by a burgeoning empire,

English aristocratic families continued to build their own collections of foreign and indigenous art. It was during the eighteenth century that the 'Grand Tour' of the Continent (particularly Italy) became an essential coda to a young gentleman's education. For many it was on these travels that they began to mould their taste and make their first purchases. These families also spent enormous sums on building or remodelling the houses where these collections were displayed. As far as London is concerned in this development, there are many examples now open to the public. Spencer House (page 92) is exceptional in that it survives in the centre of the city. Others were then in the country but now lie in the suburbs: Chiswick (page 26), Osterley (page 80), Kenwood (page 47), Syon (page 93) and Ham (page 40), for example.

Many of London's modern museums are based on collections made by discerning individuals, some of whom presented them to the nation. The British Museum (page 21), founded in the eighteenth century, and the Dulwich Picture Gallery (page 35) and the National Gallery (page 56), founded in the nineteenth century, are examples. In the twentieth century these have been added to by the collections now on display at the Courtauld Institute (page 28), Kenwood House (page 47), the Percival David Foundation (page 81) and the Wellington Museum (page 121), for example. Some have of course grown considerably since then, but from the way in which they were founded it can be seen that a process which began as the privilege of royalty and the court has ended up back in the hands of the public. It is all very democratic. In this respect the Iveagh Bequest at Kenwood House is particularly interesting. The collection of paintings and furniture is not original to the house. It was in fact put together over a remarkably short space of time during the late nineteenth century by a man who made his fortune brewing beer. But in its range and choice of items it seems deliberately to have been chosen in imitation (or even emulation) of eighteenth-century aristocratic collections.

However, the march of democracy has not entirely blunted royal patronage of the arts, even if not every monarch since Charles I has been

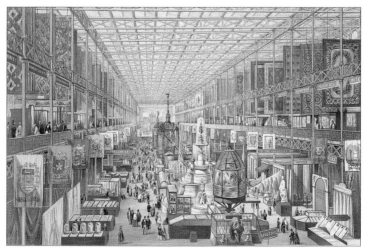

10. CONTEMPORARY PRINT OF THE GREAT EXHIBITION, 1851

In 1811, faced with the prospect of a mad king, George III, Parliament established the Regency, whereby the Prince of Wales and heir to the throne assumed the role (but not the title) of monarch. In the same year a large tract of land known as Marylebone Fields reverted to the Crown. This led to the idea to build a road joining the Prince Regent's palace, Carlton House (which was subsequently demolished in 1829 after he moved into Buckingham Palace) at the eastward end of Pall Mall, to the newly acquired parkland at Marylebone. Furthermore both the road and the perimeter of the new park were to be flanked with buildings grandly classical in design and faced with gleaming white stucco or plaster. Architect John Nash (1752–1835) was awarded the contract and construction began in 1813. In a Neoclassical sweep of rhythmically uniform stucco the route led up Regent Street, around Piccadilly Circus and past Portland Place to the open land – renamed and redesigned as Regent's Park. Nash reserved his most magnificent and palatial designs for the terraced houses (built 1821–28) that hug the southern edge of the Park. Stylistically speaking, Nash was a remarkably versatile architect. Before the Regent's Park project he had built both in an adapted Tudor and Gothic manner. During its construction he was to design Brighton Pavilion, also for the Prince Regent, this time in an exotic and eclectic eastern style. His capacity to adapt his architecture according to the requirements of a specific commission is well illustrated by All Souls, Langham Place – the church which stands at the curved junction of Portland Place with the northern tip of Regent Street. The church is sited on an awkward axis that might potentially have threatened to disrupt the ordered flow of the whole progression from south to north. As it is Nash gave the church an unusual circular portico which is pinned into place by a sharply pointed circular spire. The result is that the eye is led effortlessly around without noticing the otherwise undecorous angle of the corner.

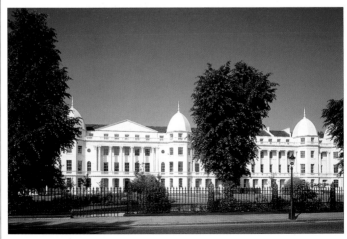

11. HANOVER TERRACE, REGENT'S PARK, 1820s

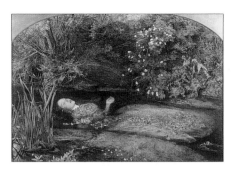

12. SIR J.E. MILLAIS, *OPHELIA*, 1851–2 (TATE GALLERY)

equally enthusiastic about the idea (see the Queen's Gallery, page 82; and Buckingham Palace, page 25). Early in the nineteenth century, for example, George IV commissioned the architect John Nash to execute possibly the grandest piece of town planning in the history of London (11). Later in the same century Prince Albert (8) was instrumental in the foundation of the Victoria and Albert Museum (page 111). Together with Henry Cole, a civil servant, Prince Albert played a crucial part in initiating and organizing the Great Exhibition of 1851. This massive international trade and industrial fair took place in Hyde Park beneath an enormous temporary structure of iron and glass – the Crystal Palace. It covered an area of around nineteen acres (10). Profits from the venture were used to set up the complex of museums at South Kensington, which includes the Victoria and Albert. On a much smaller scale it was Prince Albert who restored some of the windows of the Chapel Royal at Hampton Court (page 41) to their original state (they had been modified during the eighteenth century). He is justly commemorated for his efforts (page 18).

Traditionally art and artists have followed or been attracted to power, be it political or financial or both. But towards the end of the nineteenth century an alternative tradition of 'avant-garde' art was born. The artists concerned operated outside the existing structures which dealt with the business of art – in other words, outside the circles of royal, court or aristocratic patronage and outside the jurisdiction of the academies and art schools. In London it was the Pre-Raphaelite Brotherhood (PRB), an asso-

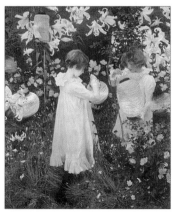

13. J.S. SARGENT, *CARNATION, LILY, LILY, ROSE*, 1865-6 (TATE GALLERY)

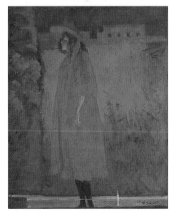

14. W.R. SICKERT, *MINNIE CUNNINGHAM AT THE OLD BEDFORD*, c. 1889 (TATE GALLERY)

15. ANDRÉ DERAIN,
*THE POOL OF
LONDON*, 1906
(TATE GALLERY)

ciation of artists founded in 1848, that first rebelled against academic orthodoxy. Pictures such as Millais's *Ophelia* (12, page 98), which seem fairly innocuous now, were considered shocking then for their brilliant colour and the literal and detailed realism of their technique. The PRB was shortlived, but its antagonistic stance was taken up by the New English Art Club (NEAC), established in 1886 with the American-born painter John Singer Sargent one of the founder members. In particular these artists rejected the belief that paintings should narrate some noble or illustrious story, urging a commitment to more mundane themes, naturalistically described. Sargent's *Carnation Lily, Lily Rose* (13) reveals that this kind of description need not preclude beautiful effects of light and colour. Walter Sickert, also a member of the NEAC, pushed these beliefs further and, for a while, produced works combining the careful description of light with aggressively modern and urban subjects (14).

The French avant garde were themselves attracted to London. Monet came to paint here in the late nineteenth century and was followed early in the twentieth by André Derain, whose *Pool of London* manages to harness a full, bright palette to the depiction of a typically dull London day (15). It has a kinship of spirit with Walter Greaves's exuberantly coloured and naively drawn *Hammersmith Bridge on Boat-Race Day* (16). A picture of an anonymous crowd enjoying themselves on a suburban bridge above the Thames, now hanging in a public gallery – this is truly democratic and a far cry from our starting point: the enlargement of an abbey on the banks of the same river by an English king in the eleventh century.

16. WALTER GREAVES,
*HAMMERSMITH
BRIDGE ON BOAT-
RACE DAY, c.* 1862
(TATE GALLERY)

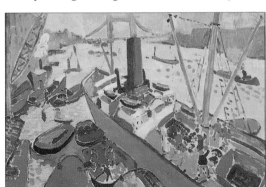

ART

IN

FOCUS

Museums

Paintings

Applied Arts

Architecture

THE ALBERT HALL AND
THE ALBERT MEMORIAL

Built 1867–71

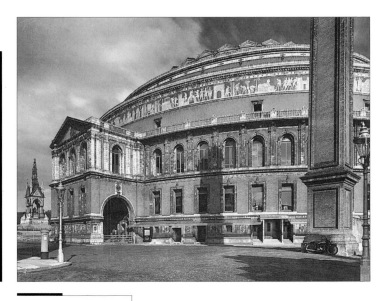

Address
Kensington Gore, London
SW7
℡ 071 589 8212

Map reference
①

How to get there
South Kensington
underground. Buses: 9, 9a,
10, 33, 49, 52, 70.

When the Albert Hall was opened by Queen Victoria in 1871 critics rather unkindly likened it to a train shed and a wedding cake whose top tier had been blown off and had landed across the road in the form of the Albert Memorial. Both were built as tributes to Victoria's husband, Prince Albert, who had died in 1861. Beneath the Gothic canopy of the memorial, designed by Giles Gilbert Scott (1811–78), the massive statue of the seated prince is surrounded by sculptures illustrating the arts and sciences he encouraged and promoted while alive. He holds the catalogue of the Great Exhibition of 1851 and looks across at the Albert Hall. This was originally intended to be London's equivalent to the Roman Colosseum, but lack of funds reduced the scale of the project. It is supported by a massive iron skeleton and used mainly as a concert hall, although it has always been dogged by acoustic problems. An ingenious Victorian heating system enabled hot air perfumed with eau-de-cologne to be pumped through the domed interior on its opening night.

(side tab) THE ALBERT HALL AND THE ALBERT MEMORIAL

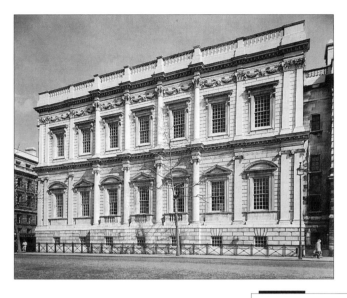

The Banqueting House is the only building to remain from the old Palace of Whitehall, the principal royal residence in London which was totally destroyed by fire in 1689. A previous fire had destroyed the old banqueting hall in 1619 and James I ordered Inigo Jones (1573–1652) to build this one, which was completed in 1622. It was a building of the utmost importance and influence in British architecture: through Jones the classical forms and principles of Italian High Renaissance architecture were introduced to Britain for the first time. The House was the centre of the Stuart court, being used for theatrical masques and for the reception of dignitaries, as well as state banquets. To create a suitable setting for these functions James I's son, Charles I, commissioned Rubens to paint a ceiling for the principal room. The paintings glorify the reign of James I – the central panel shows his apotheosis – and implicitly the very idea of kingship, as well as celebrating the unification of England and Scotland. Ironically, it was from this room that Charles stepped out on to the scaffold to be executed in January 1649.

Address
Whitehall, London SW1 2ER
✆ 071 930 4179

Map Reference

How to get there
Westminster or Charing Cross or Embankment underground. Buses: 1, 3, 6, 9, 11, 12, 13, 15, 23, 24, 29, 77, 77a, 88, 159, 168, 170, 172, 176, 500.

Opening times
Mon–Sat, 10–5; closed Sun, 25 & 26 Dec, Good Friday.

Entrance fee
£2.90. Discounts for children, students and pensioners.

Address
Cambridge Heath Road,
London E2 9PA
℡ 081 980 2415

Map reference
③

How to get there
Bethnal Green underground.
Buses: 8, 26, 48, 55, 309.

Opening times
Mon to Thur, Sat, 10–5.30;
Sun, 2.30–5.30; closed on
Fri, 24, 25 & 26 Dec, 1 Jan,
May Bank Holiday.

Entrance fee
Admission is free

Tours
Various children's events
and activities. Art
workshops every Saturday
(3 yrs upwards) and during
school holidays.

Although there are usually a few groups of children being shown round the museum, the place is rarely crowded. Most adults will probably find something here to rekindle memories long believed lost. The building itself is quite unusual, hiding an iron and glass construction behind a brick casing. It was opened in 1872 and is now part of the Victoria and Albert Museum. The collection – possibly the largest of its kind in the world – is divided into three main sections: dolls' houses, dolls and puppets, games and toys. Most items are on display though the museum also holds a substantial number of children's books which are available for research purposes only. Labels on the exhibits are very informative.

The building is divided into upper and lower galleries flanking a central hall. The former are in the process of being rearranged though at present they contain some temporary displays. In the central hall about fifty dolls' houses are displayed in cases. The earliest dates from *c.* 1760. Some of them are interesting as social documents in their own right, such as one called *Mrs Bryant's Pleasure* (a miniature Victorian interior) or *3 Devonshire Villas* copied from a real house that still stands in Kilburn. Also noteworthy here is a modernist dolls' house called *Whiteladies* from the 1930s. In the lower galleries, starting on the right and working anti-clockwise are the toys, followed on the left by puppets, games and then dolls. Particular highlights, though each visitor will find their own, include an intricate model of a guillotine carved by a French prisoner of war captured during the Napoleonic campaigns: it is made from bones salvaged from his prison rations. There are also a number of outrageously moralistic Victorian board games. The earliest doll dates from about 1680, and there are others made in India, China, Burma and Japan.

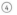

The British Museum, enormous and labyrinthine, is one of the most magnificent museums in the world. Its collections contain sculpture, jewellery and all kinds of other artefacts drawn from many different cultures and eras. Most particularly the museum is famous for its collections of antiquities – Egyptian, Greek, Roman, Assyrian and Chinese – as well as its manuscripts, prints and drawings. This wide-ranging wealth was initially founded on the library and collections of the physician Sir Hans Sloane (1650–1753) which were bequeathed to the nation at his death. To these were added the manuscripts of the First and Second Earls of Oxford and the library of the Cotton family, then owned by the Crown. Buckingham House, later to become Buckingham Palace, was considered as a site but proved too expensive at £30,000 and the Trustees purchased Montagu House on the site of the present building. This opened as the first public, secular museum in the world in 1759. Visitors, however, had to be 'of decent appearance' and entry to the museum was by ticket only. These were notoriously difficult to obtain. Visitors were also obliged to follow guides and no browsing was permitted. All this has changed.

With the expansion of the British Empire the museum's collections grew enormously in the late eighteenth and nineteenth centuries – for example with the acquisition of the Rosetta Stone (captured from the French), and the Elgin and Towneley Marbles. A new and larger building was commissioned from Robert Smirke in 1823, which was completed in 1847. It is distinguished by a grand, classical façade with a pediment frieze representing the progress of civilization. The Museum also currently houses the British Library, one of the greatest research libraries in the world, although this will soon move to a new site. Its renowned, circular Reading Room was completed by 1857 and can be visited by the public every weekday afternoon. Otherwise admission is by pass only.

Address
Great Russell Street,
London WC1B 3DG
✆ 071 636 1555

Map reference
④

How to get there
Holborn, Tottenham Court Road and Russell Square underground. Buses: 7, 8, 10, 14, 19, 22, 24, 25, 29, 38, 55, 68, 73, 77, 77a, 134, 188, 503.

Opening times
Mon to Sat, 10–5; Sun, 2.30–6; closed on 24, 25 & 26 Dec, 1 Jan, Good Friday and first Monday in May.

Entrance fee
Admission is free. A charge will sometimes be made for exhibitions

Tours
Lectures, gallery talks, films. Daily guided tours.

✪ The Parthenon Frieze
(The Elgin Marbles)

c. 432BC

Phidias

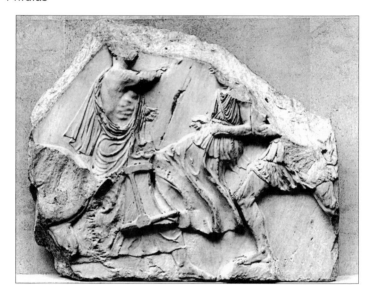

The sculpted reliefs from the Parthenon frieze were installed in the British Museum in 1816. They formed part of a donation of Classical sculptures collected by Lord Elgin. He bought the works in Athens and had them shipped back to England at considerable personal risk and expense. The British government reluctantly paid him £35,000 after the whole enterprise had cost Elgin £74,000 and two years incarceration by the French (with whom Britain was at war). In recent years the Greek government has asked for their return, but to no avail. For their beauty, realism and detail, and the skill with which they were carved within such a shallow depth, they were immediately acclaimed as the greatest pieces of sculpture ever made.

The frieze used to adorn the Parthenon, an enormous temple to Athena built on the Acropolis, the hill which overlooks the city of Athens. It was made under the auspices of the master-sculptor Phidias (sometimes Pheidias) while Athens was flourishing under the rule of Pericles. Athens was then the dominant power in Asia Minor, and Pericles wanted to adorn his city in fitting style. As a whole the frieze represents the Great Panathenaic Festival, the city's most important religious ceremony that was held every four years. It consisted of a massive procession culminating with the investiture of the great statue of Athena inside the Parthenon with the *peplos* or sacred robe. The frieze begins with horses and riders. These are followed by the charioteers (shown above) before the dignified and solemn finale. Both the charioteers and the horses start slowly, building up speed, then slowing down.

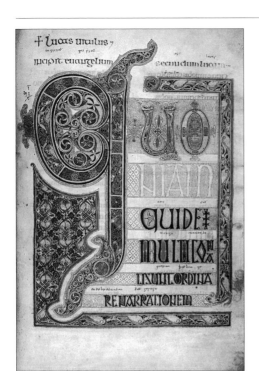

This most magnificent Anglo-Saxon manuscript of the four Gospels was made at the Northumbrian island monastery of Lindisfarne in north-eastern England towards the end of the seventh century. It was produced in honour of St. Cuthbert, a previous Prior of the monastery. Its intricately painted illuminations make it one of the very great masterpieces of manuscript art. At the end of the tenth century a priest called Aldred added the interlinear Anglo-Saxon translation of the Latin, the earliest surviving translation of the Gospels into vernacular English. He also wrote a brief history of the book on the last leaf: 'Eadfrith, Bishop of the Lindisfarne Church, originally wrote this book, for God and for Saint Cuthbert and – jointly – for all the saints whose relics are in the Island. And Ethelwald, Bishop of the Lindisfarne islanders, impressed it on the outside and covered it – as he well knew how to do. And Billfrith, the anchorite, forged the ornaments which are on it on the outside and adorned it with gold and with gems and also with gilded-over silver – pure metal. And Aldred, unworthy and most miserable priest, glossed it in English between the lines with the help of God and Saint Cuthbert ...' [translation by Janet Backhouse]. The pages are of vellum, made from calfskin (a number of hairs have been found stuck to the pages), the colours made from pigments mixed with egg white. The book was probably used in the chapel rather than the monastic library. In 875 Lindisfarne was sacked by the Vikings. The Gospels, however, were taken away to safety. In the eighteenth century they entered the British Museum as part of the library of Sir Robert Cotton.

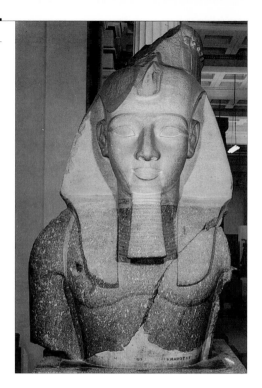

The colossal bust of Ramesses II, also known as the 'Younger Memnon', was taken from his mortuary temple, known as the Ramesseum. The majority of Egyptian sculptures were made for the tomb. Mortuary sculptures of dead kings like this one were used in rites designed to assist the after-life of the departed soul. The Ramesseum stood at Thebes near Karnak and Luxor on the Nile. Thebes was a centre of craftsmanship within Ancient Egypt, and the anonymous sculptor of this piece has displayed his skill by using a block of red and black coloured stone, carving it so that the change in colour occurs at the join between head and neck. It is in fact only a fragment of either a seated or standing statue of the king. Originally it would have been painted. As it was designed to be seen from below, the sculptor carved the eyes so that rather than face directly outwards, as was the tradition, the King's gaze is directed downwards. Common to many royal sculptures, Ramesses II is shown wearing the traditional headcloth or *nemes*. This is fitted on the brow with a device called a *uraeus*. Ramesses also wears the traditional false beard of Egyptian kings. This bust was perhaps the first piece of Egyptian sculpture to be judged of artistic as well as archaeological significance by experts disposed to evaluate everything by the standards of Greek sculpture. It was presented to the Museum in 1818 by the Swiss traveller and explorer Jean-Louis Burckhardt and the British Consul-General in Egypt, Henry Salt.

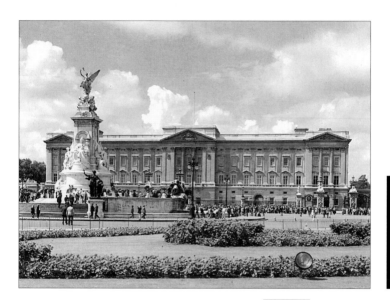

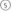

Buckingham House, built in 1705 for the Duke of Buckingham, was bought by George III in 1762. The King wrote that it was '... not meant for a Palace, but a retreat.' The transformation from domestic residence to royal palace was effected in the 1820s by the architect John Nash for King George IV. Though Nash's facade is now hidden by the new East Front, added in 1913, some of his opulent interior design survives in the eighteen state apartments now open to the public. Much of the unrivalled collection of porcelain, furniture, paintings and tapestries that are arranged here were also bought by George IV. However, in a number of the rooms on show, white and gold Edwardian decoration on walls and ceilings has replaced the more complex polychrome schemes from the mid-nineteenth century. The central spine of the building is the Picture Gallery where paintings by Titian, Rubens, Van Dyck and other masterpieces from the Royal Collection are hung.

Address
Buckingham Palace
London SW1
© 071 839 1377 ex 4204

Map reference
⑤

How to get there
Victoria underground
Buses: 2, 2b, 10, 11, 16, 24, 25, 29, 36, 36a, 38, 39, 52, 55, 70, 76, 149, 185, 500, 507.

Opening times
7 Aug–2 Oct only: daily, 9.30–5.30.

Entrance fee
£8.00. Discounts for students and pensioners.

Built 1725–29

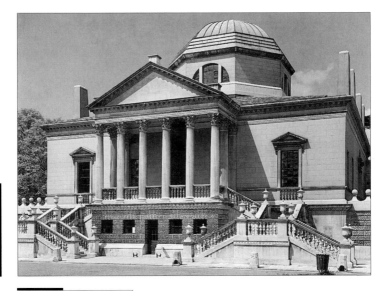

Address
Burlington Lane, Chiswick,
London W4 2RP
✆ 081 995 0508

Map reference
⑥

How to get there
Hammersmith underground,
then bus 190 or 290 at
weekends; or Turnham
Green underground, then
bus E3; or Chiswick Station
(British Rail).

Opening times
The House: 1 April–31 Oct,
daily 10–1 and 2–6; 1
Nov–31 Mar, Wed to Sun,
10–1, 2–4; closed on 24, 25,
26 Dec, 1 Jan.

Entrance fee
£2:30 adults.

Chiswick House is one of the most remarkable examples of Neoclassical architecture in Britain. An estate at Chiswick was bought by the First Earl of Burlington in 1682. His grandson, the Third Earl, Richard Boyle (1695–1753) designed and built the present house. Statues of Inigo Jones and Andrea Palladio, Lord Burlington's architectural heroes, flank the entrance: the architecture of the exterior contains numerous references to their buildings. Burlington had studied Italian Classical architecture on extensive travels through Italy and used Chiswick House to display his celebrated collection of architectural drawings (by Jones, Palladio and others), although they have since been dispersed. Here he also hung his collection of paintings, some of which still remain – for example the works by Sebastiano Ricci in the Green and Red Velvet Rooms. The house, which used to be linked to an older and larger Jacobean building (later demolished), was mainly used for receptions. Burlington did not actually live there, but kept it as a stylish and erudite setting for aristocratic social gatherings.

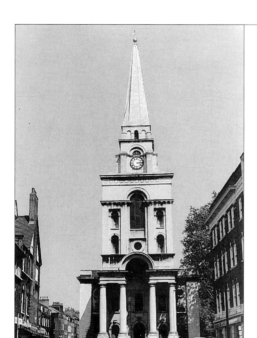

In 1711 and 1712 the newly elected Tory party passed Acts of Parliament to provide for fifty new churches in the city. As it was the party most closely associated with the established church, the project was a celebration of victory. Following the Great Fire and with the subsequent expansion of the city, new churches were needed in any case. Nicholas Hawksmoor (1661/6–1736) built six of them, of which Christ Church, designed in 1720, is one of the finest. In the early eighteenth century Spitalfields served a large community of Huguenot silkweavers, and over half of the gravestones from that period are French. The style of the church is forcefully eclectic; a dramatic combination of disparate parts. One contemporary described Hawksmoor's architecture as barbaric because it broke the rules of the ancient writers, who advocated stylistic unity. A neatened Gothic octagonal spire sits on an unusual tower. The entrance is through a portico of massive, plain classical columns. The removal of side entrances and alterations to the windows in the nineteenth century have somewhat simplified the interior.

Address
Christ Church, Spitalfields:
Commercial St, London E1
 071 247 7202

Map reference
⑦

How to get there
Liverpool Street
underground. Buses: 5, 8,
15, 15B, 22A, 22B, 26, 35,
43, 47, 48, 78, 149.

Opening times
Weekdays, 12–2.30; Sunday
services.

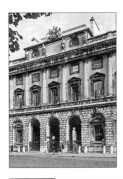

Address
Somerset House, The
Strand, London WC2R ORN
© 071 873 2526

Map reference
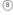

How to get there
Temple, Charing Cross or
Embankment underground.
Buses: 1, 6, 9, 11, 13, 15, 68,
77a, 188.

Opening times
Mon to Sat 10–6; Sun, 2–6.
Closed on 25 Dec.

Entrance fee
£3.00. Discounts for
children, students,
pensioners.

The Courtauld Institute is now a part of London University and housed in part of the magnificent Neoclassical building, Somerset House, built in the 1770s by Sir William Chambers, who was architect to George III. Established in 1931, it was the first institution in England to offer a degree in art history. Its benefactor was Samuel Courtauld (1865–1947). The Courtauld family were of French Huguenot descent and had settled in London by 1685. Samuel's interest in the arts was possibly stimulated in reaction to his family's Puritanism. He saw the study of art history as an important part of a wider humanist education as opposed to the narrower field of connoisseurship.

Courtauld donated the first group of French Impressionist and Post-Impressionist works to the Institute from his own collection in 1932. Though not numerous, these works are of the very highest quality and the finest of their period in a public collection in London. In fact Samuel Courtauld was one of the first to start collecting late nineteenth-century, avant-garde French painting in England. Begun in 1922 the collection was put together over a relatively short period of time. It constitutes a landmark in the history of English taste. The Galleries opened to the public in 1958. Subsequent benefactors have included Lord Lee of Fareham, the painter and critic Roger Fry and Mark Gambier-Parry, who bequeathed a number of Italian primitive paintings. In 1974 the Princes Gate collection of old master paintings was donated by Count Antoine Seilern. The Galleries occupy rooms formerly designed for and used by the Royal Academy. These have been restored to their former appearance and provide a suitably magnificent setting for the paintings, though some have complained that the wall colours are too garish and distract from the works on view.

COURTAULD INSTITUTE GALLERIES

Little is known of the early life of Quinten Massys (1465/6–1530), a Flemish artist who lived and worked almost exclusively in Antwerp. He certainly met Erasmus, painting a portrait of the humanist thinker and writer in 1517 as a gift for Sir Thomas More. It is also possible that he made one or more visits to Italy for his paintings reveal that he was aware of the revolutionary achievements of the Renaissance painters there. In this small panel, for example, the two *putti* stretching a swag of flowers across the doorway are an obvious, classical touch derived from Italian precedents. Nothing is known about the details of this commission, though the work was probably made for a rich patron as an image intended for private worship. It contains a number of unusual features, such as the sculpted figures of Old Testament prophets in the portal and the partial view of a wooded landscape combined with church architecture in the background. The presence of two angels playing musical instruments to the left is more traditional. The angel to the right offering a flower could be forgiven for over-zealousness in such a quiet and contemplative setting. Another angel can be seen in the background preparing a throne, as if Virgin and Child will soon pass through the doorway to assume a more majestic and less informal position. Northern European artists began to use oil paint, as opposed to tempera (paint made with egg), before their Italian counterparts. Massys exploits its colouristic richness here as well as the vibrant contrasts this medium could give to the description of light and shade.

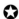
1881–82

Edouard Manet

Manet completed this work, his last major painting, one year before his death in 1883. The Folies-Bergère was a highly fashionable café in Paris. The crowds who thronged there can be seen reflected in the mirror behind the figure of the barmaid who, incidentally, was modelled by a girl who actually worked there. Clouds of cigar smoke float over the sea of shiny top-hats; one woman surveys the field through a pair of opera glasses; in the top left corner are glimpsed the legs and shoes of a trapeze artist. The painting, however, was made in the studio. As Manet worked on the picture he made certain changes to his preparatory sketches. These resulted in a number of what might be called deliberate mistakes. The position of both the barmaid and the bottles on the counter do not tally with their respective reflections in the mirror. But as these inconsistencies engage our attention it becomes evident that the gentleman whose image is reflected in the mirror has no 'real' substance. It is, in fact, as if it is the spectator whose reflection is revealed there. Since the barmaids at the Folies-Bergère also often worked as prostitutes, the viewer is turned into a prospective client. The barmaid becomes a chattel, something for sale like the bottles of beer and champagne arranged on the counter. The distracted expression on her face and the loneliness of her position serve to emphasize her vulnerability.

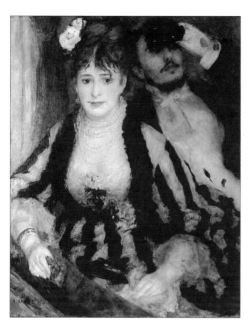

COURTAULD INSTITUTE GALLERIES

This painting was first shown in public at the exhibition in Paris where a group of young French painters earned the name 'Impressionist' on account of the sketchy technique they employed. Here, while the face of the woman is relatively focused and well defined, the rest of the painting is more summarily finished. Certain passages are particularly impressive; the bouquet on the woman's breast and the golden opera glasses are fine examples of Renoir's sensual, benevolent touch. The texture of the paint is fluid and soft. Renoir's brush seems to caress whatever it describes. In subsequent works the Impressionists were to abjure the use of black, but here Renoir has enlivened the stripes of the woman's dress by mixing black with blue in an effort to denote the effect of light passing over the fabric. Blues as well as yellows are also used for the light flickering over the whites of dress, gloves and the gentleman's shirt-front. He was modelled by Renoir's brother and is seen looking upwards out of the box, away from the stage beneath them. Someone has presumably caught his eye in another box. So while the woman is on view, he is viewing others.

In presenting us with this intimate view of Parisian nocturnal entertainment Renoir was also subverting a well-known contemporary cartoon that showed a similar scene from the theatre. In the cartoon, however, the man is conspicuously younger than the woman, who is herself clearly (and unsuccessfully) trying to conceal her age. Renoir ignores the social satire implicit in the cartoon. He also avoids referring to the loneliness of modern city life so often alluded to in Manet's Parisian paintings.

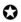
1896

Paul Cézanne

In the early 1870s, Cézanne's painting underwent a crucial transformation. He abandoned the palette knife and dark, earthy tones of his earlier works and took up the brighter, purer colours and smaller, dabbed brushstrokes of the Impressionists. Above all, he ceased painting in an impetuous, almost reckless frenzy and began to work slowly and methodically in front of nature so as to be able to attend as faithfully as possible to intricate effects of light and shade. All his former turbulent energies were turned in a different direction, subsumed in the meticulous study of nature. But Cézanne's intrinsic independence of thought and his isolation from Paris made it inevitable that once he had learned Impressionist techniques he should then develop concerns, and through these a style of painting, rather different from that of his Impressionist peers. There is, in this painting from the 1890s, little or no concession to atmospherics. Cézanne's landscape is airless; it exists as an intellectual construction or reorganization of nature's vagaries. His method of working was to build up the sense of space and volume through precise tonal relationships between one colour and the next. The whole image depended on the most exacting, rigorous and consistent balancing of his meticulously researched strokes – which the slightest error would upset. Nothing, of course, exists except in relation to its surroundings. For if things only exist by virtue of their relation to the other things around them, a contour would be too static, final and constricting. Line, therefore, is limited by its very definition.

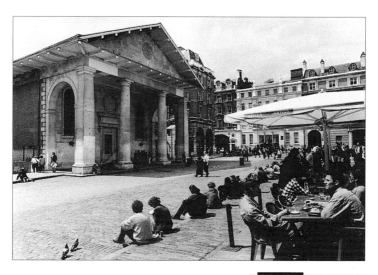

In 1630 the Fourth Earl of Bedford obtained permission to develop the site around the present Covent Garden Piazza. He commissioned Inigo Jones (1573–1652) to build not just the church but also the square and surrounding houses (the houses have all disappeared). To design so rational and self-sufficient an architectural grouping was highly unusual in England at the time and Jones based his plans on city squares he had seen in Paris and Italy. When it came to the church Bedford decided that he did not want to spend much money and, when pressed, told Jones to build him a 'barn'. 'You shall have the handsomest barn in England,' Jones is reputed to have replied. His solution was to build a simple classical temple, with a portico of massive, plain Tuscan columns supporting large, projecting eaves. The door, however, is false, and entrance is from the west side. The building is sturdy but also handsome and dignified. Many actors and composers are buried here, but the interior is relatively plain.

Address
Bedford Street, London
WC2E 9ED
 071 836 5221

Map reference
⑨

How to get there
Covent Garden or Leicester Square underground.
Buses: 1, 6, 9, 11, 13, 15, 23, 24, 29, 77, 77a, 170, 172, 176.

Opening times
Tue to Fri 9.30–4.30, Mon 9.30-2.30. Not during Sunday services.

Design Museum

Address
Butler's Wharf, Shad
Thames, London SE1 2YD.
℗ 071 403 6933 / 6261 (for
recorded information).

Map reference
⑩

How to get there
Tower Hill and London
Bridge underground.
Docklands Light Railway
Tower Gateway station.
Buses 15, 78, 42, 47, P11

Opening times
Mon to Fri 11.30–6; Sat and
Sun 12–6. Closed 25 Dec,
open on Bank Holidays.

Entrance fee
£4.50. Discounts for
children, students and
pensioners.

Tours
Free guided tours

Housed in a stylishly remodelled wharf building just down river from Tower Bridge, the Design Museum opened to the public in 1989. It is funded in part by the Conran Foundation and was established largely through the efforts and energy of its director, the designer Sir Terence Conran. The rather polemical slogan 'Industry is our culture' appeared in one of its first brochures and the museum as a whole is devoted to an informed and contextualized investigation of mass-produced consumer products: for example, the Fiat Cinquecento, Olivetti typewriters and the electric guitar. Interestingly, the French architect Le Corbusier was calling for such a museum to be created as early as 1925.

The collection divides into two parts: the Review Galleries on the first floor display examples of contemporary design within an international context. The Collection Galleries on the second floor are more historical in emphasis. Both offer a regularly changing programme of exhibitions and displays. In some respects the museum's ethos echoes the original aims behind the foundation of the Victoria and Albert Museum – that is, to provide the public (but particularly manufacturers and designers) with an opportunity to study examples of high-quality design as a spur to boosting British achievements in this field. As an aid in this or any other endeavour the museum also contains an excellent restaurant, the Blueprint Café, with a wide balcony overlooking the river.

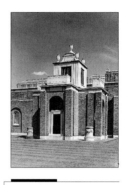

The Dulwich museum is England's oldest surviving picture gallery, founded in 1814, ten years before the National Gallery. The museum is a private institution, part of an educational foundation set up in the seventeenth century by the Shakespearean actor Edward Alleyn. The core of the collection was put together in the eighteenth century by two picture dealers, Noel Desenfans and Sir Francis Bourgeois, who benefited from London's pre-eminence in the European art market following the French Revolution. Desenfans had originally been asked in 1790 by the King of Poland to form a collection of paintings suitable for a national museum of art in Warsaw. Desenfans undertook this assignment with Bourgeois's assistance but, following the King's abdication five years later, was left without any buyer. He tried unsuccessfully to auction the pictures and even offered to sell them instead to the Russian and then the British governments. They refused and eventually the 370 paintings were bequeathed in 1811 to Dulwich School, also part of Alleyn's original foundation. It has been augmented by subsequent bequests and donations.

As a whole the collection is particularly rich in seventeenth-century painting, with major works by Poussin, Van Dyck, Murillo, Rubens, Rembrandt, Cuyp, Hobbema and Dutch seventeenth-century painters. The unusual brick Neoclassical building was designed by Sir John Soane, one of only a few of his major works to survive. It also, fittingly, contains the mausoleums of both Desenfans and Bourgeois. The gallery was partly destroyed by a bomb in 1944 but was rebuilt and reopened in 1953. All the rooms were redecorated in the early 1980s, as closely as possible to their original appearance.

Address
College Road, London
SE21 7AD
✆ 081 693 5254

Map reference
⑪

How to get there
Brixton underground and then bus or West Dulwich BR station. Buses: 37, P4 to Dulwich Village, 12, 12a, 78, 176, 176a, 185 to Dulwich Library and then walk across Dulwich Park.

Opening times
Tue to Fri 10–5; Sat 11–5; Sun 2–5; closed on Mon, 25, 26, 27 & 28 Dec, 1 Jan, Good Friday and public holidays.

Entrance fee
£2.00. Discounts for children, students and pensioners. No admission charge Friday.

Tours
Free tours Sat and Sun at 3.

Portrait of a Young Man, (the Artist's Son, Titus)

1663

Rembrandt van Rijn

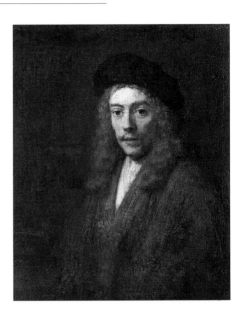

Formerly this portrait was generally considered to have been painted by a pupil or follower. However, traces of a signature and a date, 'Re ... 63', have been revealed by recent cleaning. The restoration has also exposed the abbreviated brilliance of the brushwork and no-one now can seriously doubt that this portrait is an original Rembrandt (1606–69). The sitter is sometimes identified as the artist's son Titus, who was the only one of four children born to Rembrandt from his first marriage to survive. Titus himself was to die the year before his father. But whoever the sitter may have been, this is a portrait of immediate emotional intimacy. Light strikes the shirt, forehead and left eye most brightly, fading quickly into darkness towards the edges. It is clearly the face that interests Rembrandt most. Neither the clothes, nor the setting or anything else is allowed to distract attention. Rembrandt chose to ignore one of the most common elements of conventional portraiture – the use of external trappings to portray the sitter in a flattering light. Instead he seems to concentrate on the power of paint to convey, with the utmost candour, psychological complexities as they are revealed by the human face. Here the prominent cheekbones, partially open mouth and alert eyes convey a sense of a lively, vivacious mind. At the same time, the blurred outlines and the evident gentleness with which the pigments have been put down on canvas seem to endow this portrait with tenderness and sympathy.

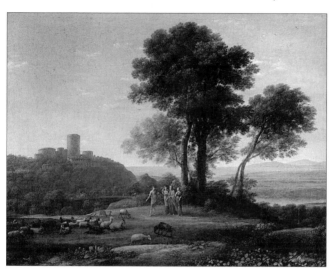

The story is taken from the book of Genesis. Jacob, the son of Isaac, falls in love with Rachel, the daughter of Laban, and agrees to look after his flocks for seven years in return for her hand. Laban then tricks him by substituting Leah, Rachel's twin sister, at the wedding and demands a further seven years' labour. Laban agrees to give him all the striped or speckled offspring from the herd as wages. Jacob then contrives it, miraculously, that all the new-born sheep and goats are so coloured.

Claude (1600–82) seems not to have focused on any one specific moment from the story – though perhaps the scene depicts Laban, flanked by his daughters, striking the deal about wages with Jacob, who is shown with a shepherd's crook. This might have been considered appropriate since the painting was commissioned by a Roman Imperial Councillor who held civic financial responsibilities. However, concerns with the narrative were clearly secondary to the depiction of landscape – as if the story were simply an excuse for Claude to create a beautiful setting. Like his contemporary Nicolas Poussin, Claude was born in France but lived and worked mostly in Rome. But where Poussin specialized in a rigorously intellectual type of painting, Claude concentrated on landscape. He sketched incessantly in the *campagna*, the countryside around Rome, transforming this landscape in his paintings into a calm and gently idealized vision of nature. The eye is led unhurriedly back, through softly rolling hills and valleys, to a horizon hazy in the distance. Contrasts of light and shade, of near and far, are included judiciously for the sake of variety, but these never jar. Claude's creation of what came to be called 'classical landscape' proved immensely popular – particularly in eighteenth-century England.

FENTON HOUSE

Built 1693

Address

Hampstead Grove,
Hampstead,
London NW3 6RT
✆ (071) 435 3471

Map reference

⑫

How to get there

Hampstead underground.
Buses: 2, 2b, 13, 26, 268.

Opening times

March: Sat and Sun only,
2–5.30; April to Oct: Sat,
Sun and Bank Holiday Mon
11–5.30; Mon, Tues, Wed,
2–5.30; closed from Nov to
Feb and on Thur and Fri.
Last entry at 5.

Entrance fee

£3.50. Discounts for
children and families.

This fine seventeenth-century house, surrounded by a walled formal garden, is one of the earliest and largest houses in Hampstead. It was built in 1693. Known previously as Ostend House and Clock House, it acquired its present name when bought by the Fenton family in 1793. They made a number of architectural changes to bring their home into line with prevailing Regency taste. Presented to the National Trust in 1952 by its last owner, it now contains part of the collection of ceramics and furniture built up by George Salting (1835–1909). Salting was an exemplary Victorian connoisseur and collector. Most of his porcelain and pictures have ended up in the Victoria and Albert Museum, the National Gallery and the British Museum. His niece, who lived at Fenton House, inherited the residue. The house also contains the Benton Fletcher Collection of antique musical instruments, bequeathed to the Trust in 1937. Concerts and recitals are regularly organized here. Recently a group of eleven paintings by Sir William Nicolson (1872–1949), collected by T.W. Bacon has been loaned. His *Hawking* (1903) hangs in the hall.

Small and unassuming, the Geffrye Museum is devoted to English interior domestic decoration. It comprises a succession of rooms arranged in chronological order from the 1600s to the 1950s, decorated and furnished with period pieces. The museum is housed in the former Geffrye or Ironmongers' Almshouses – a group of fourteen dwellings arranged around a central court (with fine plane trees) which were built in 1715 when Shoreditch was a village on the city's edge. They were named after Sir Robert Geffrye (1613–1703), twice Master of the Ironmongers' Company, who left money in his will to provide for the building of homes for the elderly poor away from the unhealthy dirt of the city slums. They were used as such until 1908.

The museum opened in 1914, and its initial intention was to educate local craftsmen: since the late eighteenth century Shoreditch had been a centre for furniture making, supplying markets in the West End. At the time of writing some of the early rooms – Elizabethan, Stuart, William and Mary and Queen Anne – were closed for refurbishment . The sequence of rooms continues past the Chapel: Early Georgian; Late Georgian – Neoclassical in flavour following the discovery of Roman remains at Pompeii and Herculaneum; Regency – reflecting the richer and more flamboyant taste of the period; Victorian – more sombre in character with the appearance of mass-produced furniture; and Edwardian – including some fine pieces by the architect and designer C.F.A.Voysey (1857–1941), who combined international Art Nouveau with traditional English styles and materials. Note also the early telephone and the Art Deco hand-pumped vacuum cleaner from the thirties. Upstairs there are two further rooms: one from just after World War One– with somewhat grim Utility furnishings; and another from the fifties, reflecting growing affluence. A projected new building will contain further twentieth-century interiors, a temporary exhibition gallery, a library and education rooms.

Address
Kingsland Road, Shoreditch, London E2 8EA
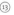 071 739 9893

Map reference
⑬

How to get there
Liverpool Street or Old Street underground. Buses: 22a, 22b, 67, 149, 243.

Opening times
Tue-Sat 10-5; Sun 2-5; closed Mon (except Bank Holiday Mondays); 24, 25 & 26 Dec and Good Friday.

Entrance fee
Admission is free.

Tours
A lively programme of events.

Built 1610

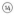

Address
Ham Street, Richmond,
Surrey, TW10 7RS
☏ 081 940 1950

Map reference
⑭

How to get there
Richmond underground
then 65 or 371 bus to Fox
and Duck Inn; 415 Victoria
to Guildford bus, alight at
Fox and Duck.

Opening times
1st April to 31 Oct: Mon to
Wed, 1–5; Sat, 1–5.30; Sun,
11.30–5.30. 1 Nov to 17 Dec,
weekends only. Closed Jan,
Feb and March.

Entrance fee
£4.00. Discount for children.
Gardens free.

Ham House, beautifully situated on the banks of
the Thames, is an almost pristine seventeenth-
century house. It was built in 1610 and in 1635
it passed into the hands of the Earls of Dysart.
Then between 1673 and 1675 Countess Elizabeth
and her husband, the Duke of Lauderdale, who
was an eminent member of the Restoration
court, remodelled the house in a style befitting
their position. Much of the decoration and fur-
niture is known to be original from an inven-
tory made in 1679. Also of note are a copy of a
painting after Henry Danckerts in the Marble
Dining Room entitled *Rose, the Royal Gardener,
presenting Charles II with the First Pineapple Grown
in England*, the Cabinet of Miniatures (at the
top of the stairs) and the portraits, including
one of the Countess by Lely in the Long Gallery.
In 1678 the diarist John Evelyn wrote, 'The
House is furnished like a great Prince's, the park
with Flower Gardens, Orangeries, Groves,
Avenues, Courts, Statues, Perspectives,
Fountains, Aviaries and all this at the banks of the
sweetest River in the World, must needs be
admired.'

Begun 1514

Hampton Court was built by Cardinal Wolsey with the express intention of surpassing every other private residence in England. Building began in 1514, but by 1529 Wolsey had been so successful in his ambition that he was obliged to hand over the palace to Henry VIII. Henry made extensive additions and Hampton Court became a favourite royal residence for the next two centuries. Further alterations were made by William III in the seventeenth century. This work was carried out by Sir Christopher Wren, who also designed the magnificent formal gardens. Subsequently it ceased to be lived in by royalty, instead being given over to 'grace and favour' apartments for those retired from royal service. The series of State Apartments, which begin on the first floor, were opened to the public by Queen Victoria. Among these is the Renaissance Picture Gallery where several fine paintings from the Royal Collection, many acquired by Charles I are displayed. The kitchens and cellars are also worth a visit, as are the maze and the covered tennis court.

Address
East Molesey, Surrey
KT8 9AU
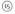 081 781 9500

Map reference
(15)

How to get there
Hampton Court Station
(BR). Buses 111, 131, 216,
267, 461; Greenline bus
715, 716, 718, 726.

Opening times
State Apts mid-Mar to mid-
Oct, daily 9.30–6, mid-Oct
to mid-Mar, 9.30–4.30;
closed 23, 24, 25 & 26 Dec,
1 Jan, Good Friday.

Entrance fee
£7.00. Discounts for
childrens, students, groups
over 15, pensioners.

41

The Triumphs of Julius Caesar

c. 1486–94

Andrea Mantegna

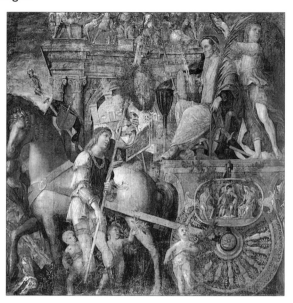

Charles I beat off fierce competition from a number of other European monarchs when he succeeded in buying this series of paintings in 1629 for the enormous sum of £10,500 from the collection of the Gonzagas, who were dukes of Mantua in Italy. They were immediately installed at Hampton Court and are now housed in the Lower Orangery, built for Queen Anne. The series depicts a triumphal procession given in Rome to celebrate Julius Caesar's victorious return from Gaul. The picture illustrated here shows Caesar being drawn on his chariot, with a triumphal arch in the background. Mantegna (1431–1503) spent his early years as a painter working in Padua, the northern Italian centre of Humanist learning. He also made a visit to Rome in 1490 to study the Classical remains there. Combining this experience with accounts of such processions in Latin literary sources, he was able to display some of his vast knowledge of ancient history and archaeology. To this end he painted in a very precise and detailed style – note for instance the medallion hanging over the wheel-axle – and had clearly also mastered the technical skills of perspective and anatomy. In celebrating the power of a Roman emperor this series obviously proved attractive to a monarch as concerned with regal authority as Charles I. They were undoubtedly made, in the first place, to proclaim the glory of the Gonzaga court. The sixteenth-century historian Vasari said that these nine tempera paintings were Mantegna's finest achievement. Unfortunately for us William III had them brutally restored in the late seventeenth century. Much of this overpainting has since been removed but the originals are clearly damaged.

Built 1840–452

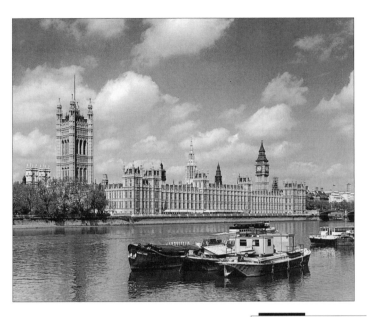

Only Westminster Hall, now part of the members' entrance, and parts of nearby St. Stephen's chapel have survived from the ancient Palace of Westminster, the former seat of Parliament. The Palace was begun by Edward the Confessor in the eleventh century and used as a royal residence until the reign of Henry VIII in the sixteenth century. Its fragile wood and plaster structure burnt down in a spectacular fire in October 1834, when the army had to be called in to control the crowds who gathered to watch and cheer. It was decided that the new complex of parliamentary buildings should be either Elizabethan or Gothic in style – partly because of the proximity of Westminster Abbey and partly because the sections that survived were original Gothic. The competition for the commission was won by Charles Barry (1795–1860) with the intricate, carved ornament outside and painted decoration inside designed by Augustus Pugin (1812–52). Barry's buildings were heavily criticized at the time: some thought them too Gothic, others not Gothic enough. Nevertheless they have seeped into the national consciousness as a symbol of British democracy.

Address
Westminster Palace, London
SW1A 0AA
© 071 219 4272 (House of Commons), 071 219 3107 (House of Lords).

Map reference
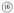

How to get there
Westminster underground.
Buses: 3, 11, 12, 24, 53, 77a, 88, 109, 159, 184, 511.

Opening times
The Strangers' Gallery is open while the House sits – usually 2.30–10 Mon to Thur; 9.30–3 Fri. Prime Minister's Question Time 2-4 Tue and Thur by ticket only from M.P.

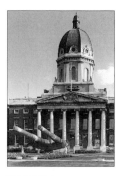

Address
Lambeth Road, London
SE1 6HZ
 071 416 5000

Map reference
⑰

How to get there
Lambeth North and
Elephant and Castle
underground; Waterloo or
Elephant and Castle BR
stations.
Buses: 1, 3, 12, 44, 53, 59,
63, 109, 155, 171, 172, 176,
188, 510.

Opening times
Daily, 10–6; closed on 24,
25 & 26 Dec, 1 Jan, Good
Friday, May Bank Holiday.

Entrance fee
£3.90. Discounts for
children, students and
pensioners.

The Imperial War Museum houses a large collection of artefacts concerned with the art of war and its social effects in the twentieth century, in particular the First and Second World Wars. The decision to found the museum was taken in 1917, before World War One had even finished. The museum opened in the Crystal Palace three years later, moving to premises in South Kensington before opening at its present site in 1936. Before that the building was the Bethlem Royal Hospital, known as Bedlam, for the insane.

The extensive and imaginative displays are concerned with all aspects of modern warfare. The museum also holds a substantial collection of works of art, 9,000 relating to World War One and a large number of works commissioned by the War Artists' Advisory Committee during World War Two. On the ground floor, for example, is exhibited John Singer Sargent's monumental canvas, *Gassed*. The main collection of paintings is shown in the second floor galleries. Works by First World War artists include pictures by Wyndham Lewis, Paul Nash, Henry Tonks and Stanley Spencer. Second World War artists include Edward Ardizzone, Henry Moore, John Piper and Graham Sutherland. Pictures not on show can be seen by appointment.

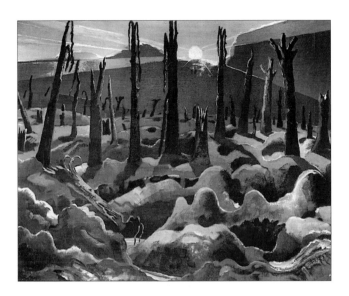

Paul Nash (1889–1946) only decided to become an artist after a series of professional disasters. He failed to gain entry to the Navy, thought briefly about a career first in architecture and then in banking, before becoming an art student in London. In 1914 he joined the Artists' Rifles and in 1917 he was sent to Ypres, where he later became an official war artist. As a landscape painter first and foremost, his paintings concentrated more on the war's ravages of nature than they did on the men who had to fight in these surroundings. In this stark, symmetrical and emblematic landscape, broad, flat rays of light break over the earth from a centrally positioned sun. The trees remain unidentifiable stumps within this churned and pitted country, the shell craters ridged like waves.

This picture was painted in the last year of the war, but it would seem too glib to imagine that the sunrise indicated the beginning of a new, more hopeful era. For we are just as free to see this landscape itself as the new world Nash refers to in the title. In fact in November 1917 he had written to his wife: 'Sunrise and sunset are blasphemous, they are mockeries to man, only the black rain out of the bruised and swollen clouds all through the bitter black of night is fit atmosphere in such a land. The rain drives on, the stinking mud becomes more evilly yellow, the shell holes fill up with green-white water, the roads and tracks are covered in inches of slime, the black dying trees ooze and sweat, and the shells never cease ...'

Built 1605

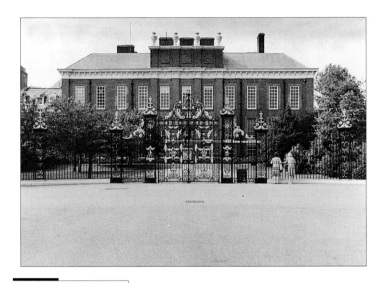

Address
Kensington Gardens,
London W8 4PX
✆ 071 937 9561 ext. 20

Map reference
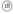

How to get there
Queensway underground.
Buses: 9, 9a, 10, 12, 27, 28,
31, 33, 49, 52, 70, 88, 94.

Opening times
Mon to Sat, 9–5; Sun, 11–5.
Last tickets 4.15.

Entrance fee
£4.50. Discounts for
children, students and
pensioners. Family tickets.

William III bought the palace from the Second
Earl of Nottingham in 1689 for £18,000. Until
the death of George II in 1760 it was a royal res-
idence. The original house, dating from 1605,
was remodelled by Wren and Hawksmoor, and
the exterior is now much as they left it. Further
major alterations were made to the interior in the
early eighteenth century for George I by Colen
Campbell and William Kent, effectively turning
the house into a palace. William and Mary,
Queen Anne and George II died here, and Queen
Victoria and Queen Mary were born here in
1819 and 1867 respectively. The State
Apartments were first opened to the public in
1899 and renovated in 1975; the rooms now
house fine examples of paintings and furniture
from the Royal Collection. The palace is also
remarkable for the number and quality of paint-
ed ceilings that survive by the hand of William
Kent: his ceiling in the Presence Chamber is the
first example of the Pompeian style of decoration
in England. The King's Gallery, remodelled by
Kent in 1725–26, contains Rubens's *Jupiter and
Antiope* and other important paintings by Dutch,
Italian and Spanish artists.

There are two reasons for visiting Kenwood House: first for the magnificent Neoclassical interiors by Robert Adam (1728–92), and second for the superb collection of paintings given to the nation as part of the Iveagh Bequest. The house was bought by William Murray (1705–92), First Earl of Mansfield and Lord Chief Justice to George III. Between 1764 and 1779 Mansfield employed Robert Adam to remodel and extend his home. Mansfield himself had no substantial collection of paintings, and as a result the house contains no gallery. Instead Adam's magnificent suite of reception rooms culminate in the Library or Great Room, which many consider to be his masterpiece. In 1925 the house and extensive grounds, now within London itself, were nearly lost to property speculators anxious to develop such a large site. Though almost all the original furniture was sold, both house and garden were bought by Edward Cecil Guinness (1847–1927), First Earl of Iveagh. He refurnished it in order to hang his remarkable collection of paintings, mainly English, Dutch and Flemish, and bequeathed it all to the nation after his death.

Address
Hampstead Lane, London
NW3 7JR
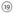 081 348 1286

Map reference
⑲

How to get there
Archway or Golders Green underground followed by bus 210.

Opening times
1 April to 31 Oct, 10–6;
1 Nov to 31 March, 10–4;
closed 24 & 25 Dec.

Entrance fee
Admission is free. Large parties must book in advance.

Mary, Countess Howe

c. 1763–64

Thomas Gainsborough

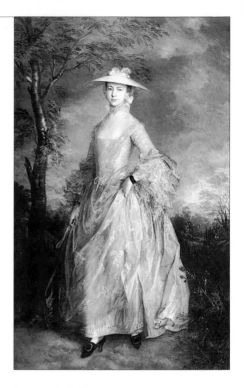

Gainsborough (1727–88) was born in Suffolk, where he first started to practise as a portrait painter. In 1759 he moved to the fashionable spa-town of Bath, in the south-west of England, in order to attract more commissions from the wealthy aristocrats who went there. This portrait was painted a few years after his arrival. Mary Hartopp (1732–1800) married Richard Howe, an admiral in the Navy and later Earl Howe, in 1758. Gainsborough paints her strolling through parkland, with a breeze rustling the pink silk of her dress and folding back the diaphanous lace apron. She wears a simple straw hat yet the whole effect is one of aloof and assured elegance, and of formidable beauty.

Gainsborough's works proved immediately popular with the aristocracy. The easy, stylized grace which his fluid brushwork lent his sitters created just the image they themselves wished to present. It seemed to combine formality with just the right amount of informality, without compromising his sitters' sense of their own dignity and importance. In developing this magical and very successful formula Gainsborough was probably influenced by the court portraits of Van Dyck, which he would have seen at the country houses that he visited in the area. Ironically, he stated that he hated painting portraits and would have preferred to concentrate on landscapes instead, but that he needed the money. Landscape painting was considered a far inferior branch of painting at the time, a situation that only really changed in the following century.

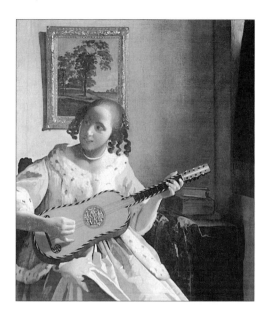

Little is known about Vermeer (1632–75). He was born and died in Delft, the son of a silk merchant who was also an art dealer and an innkeeper. There are no records of sales of any of his paintings, of which only about thiry-five are known. Iveagh bought this work in 1889 at a time when Vermeer's reputation had only just begun to emerge from obscurity. This is the only one of his paintings, apart from those in the National Gallery and the Royal Collection, on public show in England.

In *Guitar Player* a woman, possibly Vermeer's wife, plays a guitar in a room. Deliberately positioned off-centre in the composition she turns her head to the left as if her attention has momentarily been caught by an unseen presence. Yet she seems at the same time completely unaware of the artist's gaze. In this sense Vermeer's paintings are supremely evasive, emotionally neutral – yet utterly precise in design and execution. As one writer has put it, they are triumphs of passivity. There is no erotic story here, as was usual in similar interior scenes by contemporary Dutch painters. Everything has been crisply described but there is no sense of texture nor of contour. Only light counts in this silent, impersonal and detached vision – glittering on the picture frame behind and lucidly modelling the sitter's face and hands. It is possible, however, that with the picture, guitar and book Vermeer intended to allude to the three sister arts of painting, poetry and music – with the lone presence of a woman to suggest some kind of link between the creative and the feminine principle.

✪ Portrait of the Artist

1665

Rembrandt van Rijn

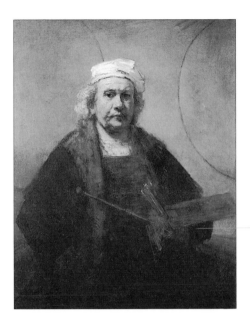

Rembrandt (1606–69) painted around sixty self-portraits during his lifetime. As a young man, and a successful artist working in Amsterdam, his self-portraits show Rembrandt full of confidence, often in exotic costume or splendidly rich clothes. By 1665 when this was painted, however, he had declared himself bankrupt and was employed as an artist by his son Titus to avoid his creditors. A couple of years before, his beloved mistress, Hendrijke Stoffels, had died of the plague. He could not even afford to pay the rent for her grave and was obliged to live off their daughter's savings. Yet if Rembrandt's expression here seems resigned, it is also full of dignity and calm; it gives no hint of all the disasters that had befallen him. He portrays himself in a still and solemn pose. Though he is holding palette and brushes, they are simply props as he does not use them. The circles in the background are unexplained: the picture is unfinished, and they may have been intended to represent circular world maps popular in drawing rooms in Dutch households at the time. If so, then Rembrandt has positioned himself away from the informality of a studio setting to create a more formal portrait. He is certainly not using the external trappings of his work to mask private pain: the expression is unflinchingly lucid.

Leighton House was home to Frederick, Lord Leighton of Stretton (1830–96) for the last thirty years of his life. He was President of the Royal Academy and the leading Victorian artist of his time. The house was built in collaboration with the architect George Aitchison in 1866 as a purpose-built studio as well as a home, one of the first of its kind in London. Its plain brick exterior hides a fabulously rich interior which is particularly notable for its collections of tiles (both Persian and Saracen), Victorian ceramics and furniture, and also Victorian paintings by Leighton and his contemporaries. Most spectacular of all is the Arab Hall on the ground floor. The other rooms on the ground floor are the Library, Drawing Room and Dining Room. These last two look out over the garden, with a good view of Leighton's large bronze statue *Athlete Struggling with a Python* (1877). The stairwell contains a display case of ceramics by William de Morgan; also here are a number of Leighton's own paintings including a copy of Michelangelo's *Creation of Adam* from the Sistine Ceiling in Rome. To the north of the landing is the Great Studio, the heart of the house.

Address
12 Holland Park Road,
London W14 8LZ
© 071 602 3316

Map reference
20

How to get there
Kensington High Street underground. Buses: 9, 9a, 10, 27, 28, 31, 33, 49.

Opening times
Mon to Sat, 11–5.30; closed on Sun and Bank Holidays. Garden is open from April to Sept.

Entrance fee
Admission is free.

Tours
A charge is made for guided tours (minimum 15 persons) – by prior arrangement with the Curator.

LINLEY SAMBOURNE HOUSE

Built 1868–74

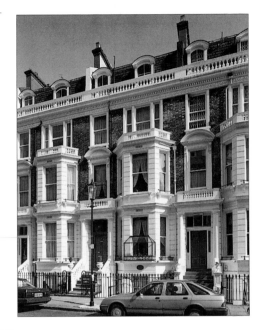

Address

18 Stafford Terrace, London
W8 7BH

✆ 081 994 1019 (The
Victorian Society)

Map reference

㉑

How to get there

Kensington High Street
underground. Buses: 9, 9a,
10, 27, 28, 31, 33, 49, 70.

Opening times

March to Oct, Wed 10–4;
Sun 2–5. Groups may visit
at other times by prior
arrangement with The
Victorian Society.

Entrance fee

£3.00. Discounts for
children, students and
pensioners.

Linley Sambourne House was originally the home of Edward Linley Sambourne (1845 –1910), chief political cartoonist of the satirical magazine *Punch*, who lived here from 1874 until his death. It was given to the nation by his grand-daughter, Lady Rosse. The exterior is that of a typical classical, Italianate Victorian terraced house, distinguished from its neighbours only by some ingenious glazed window boxes. Inside, however, the house is exceptional for its original interior decoration. The pictures, ceramics and furniture are arranged virtually as Sambourne left them. The house, with its crowded walls, rich patterns and stained glass, vividly conveys the somewhat stuffy atmosphere of a well-to-do, upper-middle class Victorian household. The hall is hung with many pictures including some of Sambourne's cartoons. Also on the ground floor are the Dining Room and Morning Room. Upstairs the Drawing Room occupies the whole of the first floor. On the second floor, facing the front, is Lady Rosse's Bedroom – here hang seven impressive drawings by Sambourne as well as a fan in front of the fireplace, ornament-ed and signed by his artist friends.

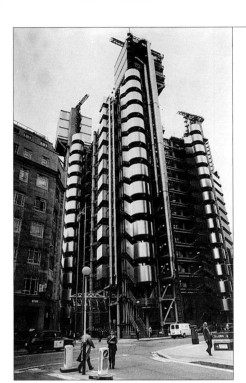

This is a deliberately and conspicuously different building. Architect Richard Rogers, co-designer of the controversial Pompidou Centre in Paris, was an unusual choice for such an established and conservative institution as Lloyd's, but the adventurous spirit of their patronage has been justifiably praised. For the public, denied access to the inside, it is the exterior impression that counts. Crowded and detailed, alternately transparent and opaque, and deliberately concealing the symmetrical arrangement of its central core, the building gives a vivid and dramatic impression of corporate and city life. It is also, for all the glass, concrete and steel, eclectic in its historical references. The service towers and cranes respond to the spires of the city churches and the glazed barrel vault of the atrium is an explicit reminder of the kind of Victorian industrial architecture seen in Leadenhall Market next door.

Address
1 Lime Street, London
EC3 7HR
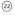 071 623 7100

Map reference
㉒

How to get there
Bank, Monument, Liverpool Street or Aldgate underground.

Opening times
For security reasons the interior is no longer open to the public.

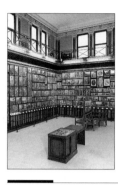

Address
Royal Botanic Gardens,
Kew, Richmond, Surrey,
TW9 3AB
✆ 081 332 5000

Map reference
㉓

How to get there
Kew Gardens underground;
Kew Bridge Station (BR).
Buses: 39, 65. Boats from
Westminster Pier to Kew
Pier.

Opening times
Daily, opens at 9.30, closing
times vary throughout the
year at dusk. Preferable to
ring first.

Entrance fee
£4.00. Discounts for
children, students and
pensioners. Family day
ticket £10.

Tours
Guided tours from Victoria
Gate Visitor's Centre 11–2

Marianne North (1830–90) was an independent Victorian spinster and a spirited traveller, who could not bear, as she put it, having her time 'wasted by cardleaving, dressing up and missionaries.' From 1871, following the death of her father when she was forty-one, until 1884, she travelled all over the world painting tropical and exotic plants, insects and views. Her voyages included Egypt, South America, Japan, India, Indonesia, Australia and South Africa. The Marianne North Gallery, a separate part of the Royal Botanic Gardens at Kew, houses over 800 of her works in a charming gallery designed along the lines of a Greek temple. It was paid for by the artist herself and built by her friend John Ferguson; it is lit by an unusual clerestory, rather than the more normal skylight.

The first impression is dazzling – North stipulated that her brightly-coloured paintings should be hung so close together that no wall space would be visible between the frames. One writer has likened the effect to that of a 'botanical postage-stamp album'. Victorian young ladies of leisure were encouraged to paint flowers as a prelude to the more exacting demands of marriage and childbirth. North applied her skills more directly, by neither marrying nor having children. Incidentally, some of the plants she depicted were previously unknown – four species and one genus now bear her name.

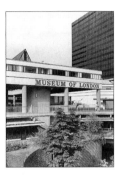

The Museum of London opened in 1976, combining two former museums – the Guildhall Museum founded in 1826 and the London Museum founded in 1911. It is situated adjacent to the Brutalist, concrete complexities of the Barbican Centre (London architecture from the 1960s, arguably at its worst), although at two points within the museum it is possible to look out on to the old, medieval city walls. The collections, illustrating the history of the capital, are arranged on two levels and the displays follow one another in chronological order. They are distinguished by their attention to detail and unusual items. For example, there is musical accompaniment to the section dealing with Tudor London; while the Roman section deals with trade, make-up and dancing-girl costumes as well as techniques of warfare and building. This part of the museum also contains a reconstruction of three rooms from a Roman villa in London. The interior decoration seems startlingly modern. Other highlights on the upper floor include a hoard of jewellery dating from Tudor and Stuart times, found in 1912 in Cheapside, and a model of the Rose Theatre, Southwark, near where Shakespeare used to perform. There follows a dramatic audio-visual reconstruction of the Great Fire of 1666 with eyewitness extracts from the diary of Samuel Pepys. Moving downstairs, past the garden in the central well, there is a detailed display of the rebuilding of London following the Fire, including a useful section on the rebuilding of St. Paul's. Also here is the magnificently gaudy Lord Mayor's State Coach built in 1757. As well as artefacts and displays the museum holds a substantial collection of paintings. Not all of these are shown at any one time, but especially noteworthy among them are a painting of Covent Garden market from the eighteenth century by Samuel Scott and one by Abraham Hondius showing a fair held on the Thames when it froze in about 1683.

Address
London Wall, EC2Y 5HN
℅ 071 600 3699

Map reference

How to get there
Barbican, St Paul's and Moorgate underground.
Buses: 4, 56, 172.

Opening times
Tue to Sat, 10–5.30; Sun, 2–5.30; closed on Mon, except Bank Holidays, 25 & 26 Dec.

Entrance fee
£3.50, although the ticket allows unlimited returns to the museum over a period of three months. Admission is free after 4.30. Parties of more than 15 people must book in advance. Discounts for children, students and pensioners.

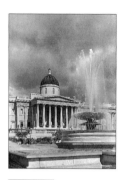

Address
Trafalgar Square, London
WC2 5DN
 071 839 3321

Map reference
㉕

How to get there
Charing Cross or Leicester
Square underground Buses:
3, 6, 9, 11, 12, 13, 15, x15,
23, 24, 53, 53x 77, 77a, 88,
91, 94, 109, 139, 159, 176,
609.

Opening times
Mon to Sat 10–6 (Wed 10–8
during summer); Sun 2–6;
closed on 24 & 25 Dec,
Jan 1, Good Friday, May
Bank Holiday.

Entrance fee
Admision is free. Charge for
temporary loan exhibitions.

Tours
Lecture tours (English) at
11.30 and 2.30 Mon to Fri;
2 and 3.30 Sat.

The Collections

The National Gallery opened in 1824 at sub-
stantially smaller premises close by in Pall Mall;
that year the Government spent £57,000 on
acquiring for the nation the collection of John
Julius Angerstein (1735–1823), who had died
the previous year. It thus differs from a number
of the other major European national galleries,
such as those in Paris, Vienna and Madrid, in
that the collection did not formerly belong to
the monarchy. At the insistence of the then Prime
Minister, Lord Liverpool, children under the
age of seven were granted entry – unlike at the
British Museum – because otherwise, he argued,
a whole generation of working-class mothers
(who could not afford nannies) would also in
effect be barred. It was soon realized that a larger space
than that in Pall Mall would be needed, and in
1839 the present purpose-built gallery (designed
by William Wilkins) was opened on the site of
the former Royal Mews, Trafalgar Square. By
1855 the gallery was given an annual grant for
purchases, with the aim of forming a compre-
hensive collection of European painting. In this
the gallery's successive directors have been
remarkably successful, creating a collection that
is not only representative of all the major schools
and figures of European painting but also one of
the very highest quality. Initially Italian
Renaissance paintings were preferred above any
others, but now the collection ranges from the
thirteenth to the early twentieth centuries. The
recent loan of the Berggruen Collection of main-
ly late nineteenth-century French painting has
considerably strengthened one area of possible
weakness.

The lavish interiors of the original building
were mainly designed by E.M. Barry (1867–76)
and have recently been restored. These rooms
provide an interesting contrast to the modern
extension to the north, opened in 1975, and in
particular to the Sainsbury Wing, opened in
1991, to the west.

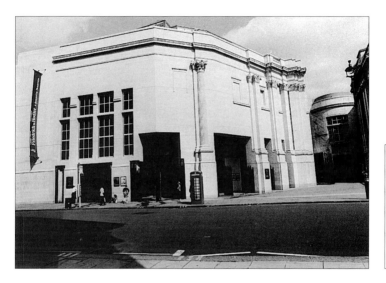

The Building

This newest extension to the National Gallery was designed by the architectural partners Venturi, Rauch and Scott Brown of Philadelphia and opened in 1991. It was paid for by a handsome endowment from the Sainsbury family, owners of a national supermarket chain. The 'postmodern', classical design met with the approval of Prince Charles after he had initiated much public debate on alternative, more uncompromisingly modernist proposals. This design, at the very least, has the virtue of complementing the facade of the original building on Trafalgar Square. On the ground floor are a large, well-stocked shop and cloakroom. Downstairs there is a lecture theatre and space for temporary exhibitions. The mezzanine contains a restaurant, conference rooms and an interactive, computerized catalogue of the collection (Micro Gallery). A great staircase, relatively rare now in a public building, leads upstairs to the collection.

The earliest paintings, from the thirteenth to the end of the fifteenth centuries, are now housed here because the temperature, humidity and light can be fully controlled. The interior walls, painted a pale grey with grey, sturdy pillars in the door arches, provide a modern variant on the architecture of the Florentine Renaissance – in particular the buildings of Brunelleschi. Vistas interlock on a not quite symmetrical grid. At the end of each of these axes individual paintings are prominently displayed, visible from a distance. It is all quite enticing. The paintings described in the following pages chart a route from the Sainsbury Wing towards the Trafalgar Square entrance.

The Wilton Diptych

c. 1395

French school

The word 'diptych' means simply a pair of hinged panels or paintings. This example is so named because it was for a long time in the possession of the Earls of Pembroke at Wilton House in Wiltshire. It also belonged at one point to King Charles I. The main panels show the kneeling King Richard II (who reigned from 1377 to 1399) being presented to the Virgin and Child, who are accompanied by assembled angels. The figures next to Richard are St. John the Baptist, holding a lamb, and two other English kings: St. Edward the Confessor, founder of Westminster Abbey, who is shown holding a ring, and St. Edmund, shown holding the arrow of his own martyrdom. These three kings are all richly dressed and wearing crowns so that the scene fancifully refers to the *Adoration of the Magi*, thereby cleverly transforming Richard into one of the Wise Men. Richard's own birthday fell on the Feast of the Epiphany, making this connection all the more appropriate. Furthermore John the Baptist was one of his favourite saints since he acceded to the throne the day before that saint's feast day. The white hart was also Richard's personal badge or emblem and can be seen in several forms throughout the panels. It is embossed into the gold of Richard's robe and worn by each of the eleven angels. It also appears on the outside of the diptych.

This painting was one of the most inspired purchases of the Gallery's first director, Sir Charles Eastlake. He bought it in 1861 for £241 – a bargain when compared with the £1,000 spent the following year on a portrait by Gainsborough of the actress Mrs Siddons – long before Piero's reputation as one of the greatest masters of the early Italian Renaissance had been firmly established. Piero della Francesca (c. 1410–1492) lived and worked for the most part in the small town of Borgo San Sepolcro in Umbria, Italy. The landscape which surrounds the figures of Christ, St. John the Baptist, the angels and other figures is recognizably that of the Umbrian countryside; the walls and towers of the San Sepolcro can be glimpsed between Christ's hip and the nearby tree. Piero was very unusual during his own lifetime in providing his figures with topographically accurate settings, though this probably greatly pleased his patrons. His paintings are also greatly admired for the lucid calm of their design. This is in part undoubtedly due to Piero's own interest in mathematics, a subject on which he wrote two treatises. The composition here can be divided into thirds, both horizontally – along the axis of the dove's outstretched wings and that of the Baptist and angels' hands – and vertically – along the axis of the tree and that of the Baptist's back. Such geometric configurations lend the image a peculiar stillness and dignity, qualities that are matched by the solemn expressions of the protagonists.

Madonna of the Meadow

1500–10

Giovanni Bellini

With his bright, full colours and the sensuous description of light (here, a crisp, spring morning) Giovanni Bellini (*c.* 1430-1516) has been seen as a kind of father-figure of Venetian painting. Light and colour certainly seem central to the legacy Bellini handed down to his two most famous pupils, Giorgione and Titian. One of Bellini's many talents was his ability to integrate the description of light with his chosen subject. Here Mary looks down reverently at the child asleep in her lap. But the pose of the Christ child deliberately recalls that of the *pietà*, or the image of the Virgin mourning the dead Christ who is lain across her lap. The carrion bird in the tree contains another reference to death. The seasonal reference to spring thus alludes to the time of year of the Passion. The stork fighting with a serpent to the left refers to Christ's final victory over Satan and death.

Mythological Subject (Death of Procris?)

c. 1500

Piero di Cosimo

The subject of this panel, by the Florentine artist Piero di Cosimo (*c.* 1462–1521?), has never been satisfactorily explained. It might represent the death of the nymph Procris who, unjustly suspecting her husband Cephalus of adultery, secretly followed him on a hunting trip to spy on him. Cephalus, unaware he was being watched and hearing a noise in a nearby bush, threw his spear at what he thought was a wild animal. His weapon killed Procris instead. Here however, it is a faun rather than Cephalus who mourns the dying woman. But whatever the actual subject, Piero di Cosimo's skill in conveying pathos is easily appreciated. The dog on the right looks particularly sad and dejected. Piero di Cosimo himself was something of an eccentric. According to one account he disliked the noise of city life, lived on a diet of hard boiled eggs, and was terrified of lightning.

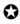

Reputed to have been acquired by a British soldier after the Battle of Waterloo, Jan van Eyck's *Arnolfini Marriage* is one of the finest examples of Early Netherlandish painting in the collection. With meticulous attention to detail, Van Eyck (active 1422, died 1441) has described the interior of a wealthy merchant's home in Bruges. In particular he has taken care to distinguish between the different textures of the objects and forms depicted. The merchant was Italian, a man called Giovanni Arnolfini, who married the daughter of an Italian silk merchant named Giovanna Cenami. The painting is believed to be their wedding portrait, and the objects included in the room are likely to contain symbolic references to marriage. So for example, the dog at Giovanni's feet can be seen as a symbol of fidelity, something also indicated by the colour green of Giovanna's dress. The oranges on the sideboard signify wealth and fertility, while the figure carved on the bedpost is St. Margaret, patron saint of childbirth. The single lit candle and the fact that man and wife have taken off their patten shoes indicate that the couple are standing in the presence of God. Furthermore, Giovanni's raised hand tells us that he is swearing an oath. It seems then that the picture records the marriage service itself, with the giving and receiving of loyal vows. The signature just above the mirror on the far wall, 'Johannes de Eyck fuit hic 1434', in Latin and written in a flourishing legal script, indicates that Van Eyck was present not only as the artist but also as witness to the ceremony. His presence can be dimly made out in the mirror's reflection.

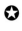
✪ Cartoon: The Virgin and Child with St. Anne and St. John the Baptist

mid 1490s

Leonardo da Vinci

The word cartoon is derived from the Italian *cartone* meaning a large sheet of paper on which the artist drew an image that served as a kind of template for the finished painting or fresco, usually pricking the contours with a sharp instrument. Charcoal dust would then be brushed over the holes so that the outline of the cartoon could be transferred to the wall or wood panel. This cartoon dates from the mid-1490s and is in black chalk, highlighted with white, on several sheets of reddish buff paper. It was in fact never pricked, so it is possible that it was not intended for a painting but was considered by Leonardo as complete in itself. Leonardo's was a restlessly inventive mind, constantly probing at the limits of human knowledge. Here he has combined two traditional themes in one image: the Virgin and Child sitting in the lap of St. Anne and the Virgin and Child with St. John the Baptist. His characteristic and virtuoso technique of shading, known as *sfumato*, models his figures with subtlety and tenderness, as well as giving them monumental stature. While the Christ child raises his hand in a gesture of benediction, St. Anne points upwards to the heavens to indicate the spiritual significance of these halo-less figures. Sigmund Freud was so moved by this image of gentle motherhood that it prompted him to write an analysis of Leonardo's personality.

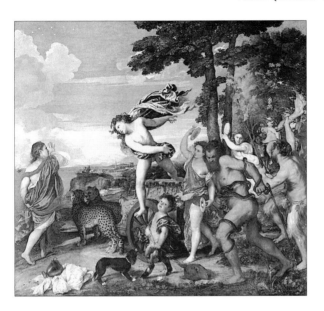

Titian (*c.* 1487–1576) painted this canvas for Alfonso d'Este, Duke of Ferrara, as one in a series of works emulating lost masterpieces of antiquity. As befitted such a learned theme, it was to hang in his private study. Titian takes the details of his story from a variety of Classical sources – in particular from descriptions found in the Latin poems of Ovid, Philostratus and Catullus. Ariadne, on the far left, had saved the life of the hero Theseus in his fight against the minotaur in Crete. They had then sailed away together, but on the island of Naxos Theseus abandoned her. It is dawn and Ariadne is seen watching Theseus's ship depart over the horizon. Meanwhile Bacchus, the god of wine, flying over the island, has spied Ariadne and fallen in love with her. He comes down to meet her accompanied by his retinue of drunken followers, some of whom are making music while others brandish parts of a calf they have dismembered with their bare hands. Titian shows Bacchus leaping from his chariot, frozen in mid-air, as Ariadne spins round in alarm. Perhaps the moment of intervention of divine aid into matters of mortal misery is bound to be a noisy affair. Certainly the painting bristles with ecstatic energy and movement, both in the dynamic poses of the figures and the intensity of the colour. Yet one of the two cheetahs, the only beings present who remain calm, looks on rather haughtily at the extraordinary events taking place behind them.

Allegory of Love

c. 1550

Agnolo Bronzino

Venus, holding a golden apple, is shown in incestuous embrace with her son Cupid. While he is provocatively grasping her breast, she prepares to give him a more than innocent kiss. At the same time, to their right, a smiling boy is about to shower them with rose petals. He remains oblivious to the thorn which has pierced his right foot: and for this he is identified as Folly. Behind him crouches Pleasure, with a girl's face on a reptilian body, who is seen holding out a honeycomb with one hand while hiding the sting in her tail with the other. To the left the agonized green figure tearing out her hair is Envy. So far the moral of this allegorical grouping seems quite clear – incestuous or irresponsible love might well be pleasureable but is something only foolishly entered into. Envy will, in the end, destroy any such relationship. Indeed, Envy's withered skin, arthritic joints and toothless grimace provide a graphic illustration of the symptoms of syphilis. The mask above them possibly represents Fraud; and in the top right corner Time, with his hourglass, seems anxious either to expose or cover up all this depraved activity. Bronzino painted this allegory for Cosimo de'Medici, Duke of Florence, who may have intended it as a gift for the King of France, Francis I. Whatever the case, Bronzino's deliberately artificial style – his distorted figures with their polished white skin – seems to have been aimed at a sophisticated audience that would probably have enjoyed trying to unravel the ingenuities of his allegory.

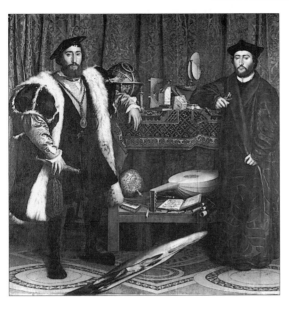

The extraordinary shape in the foreground of this painting represents a human skull seen in elongated perspective. It is recognizable as such when viewed from the bottom right-hand corner. Its prominence suggests that it must somehow explain the relation between the two figures and the collection of miscellaneous objects arranged on the table. The figure on the left is Jean de Dinteville, French ambassador to the court of Henry VIII where Holbein (1497/8–1543) spent most of his career. In April 1533 De Dinteville was visited by a friend Georges de Selve, who is seen on the right dressed as a cleric. De Dinteville was twenty-nine years old as the inscription on his sword informs us. A similar inscription on the book upon which De Selve leans his elbow tells us that he was twenty-five.

The precise significance of the objects on the table has never been fully explained. On the top shelf, however, are arranged instruments that are all connected with the heavens: a celestial globe, sundials and quadrants. On the lower shelf the objects are concerned with terrestrial knowledge: music, mathematics and the other arts. The lute, however, has a broken string which may signify the transience of human life and therefore the essential futility of human learning and achievement. This kind of message would of course tally with the presence of the skull. It seems that Jean de Dinteville took this painting back with him to France – perhaps as a sober reminder that worldly success was no guarantee of eternal life.

Equestrian Portrait of Charles I

1638

Sir Anthony

van Dyck

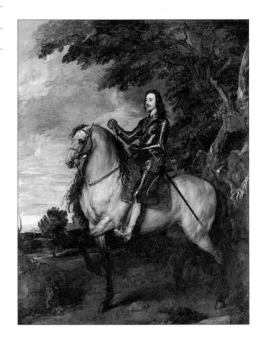

Charles I invited the Flemish artist Anthony van Dyck (1599–1641) to England in 1632, where he remained until his death in 1641. In return Van Dyck was given a knighthood. This magnificent, grand portrait, which was painted three years before the artist's death presents Charles in full, regal majesty as he sits calmly astride a nervous and excited horse. The animal is frothing at the mouth, its long hair curling as if in energetic sympathy with its quivering muscles. The King's confidence and poise can only be enhanced by the contrast: he was in fact renowned for his skill as a horseman. Charles wears armour made at Greenwich while around his neck hangs the Order of the Garter.

It was the ancient Romans who first had the idea of displaying equestrian statues of the emperors in public as an expression of their power and pre-eminence. In emulating those precedents here Van Dyck was deliberately celebrating the very idea of Kingship at a time when it was seriously under threat from the English Parliament. The painting used to hang prominently and publicly at the end of a long corridor at Hampton Court. Only four years after it was finished the English Civil War broke out. At the end of it Charles himself was executed, beheaded by order of Parliament outside Inigo Jones's Banqueting Hall in Whitehall (page 19).

Thomas Gainsborough

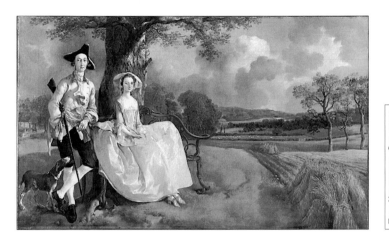

Gainsborough (1727–88) trained as an artist in London and when he was about twenty years old returned to his native town of Sudbury in Suffolk. Here he made a living painting portraits, often placing his sitters in a landscape setting. Mr. and Mrs. Andrews married in 1748; this portrait was made a year or two later. They have been presented as an essentially Augustan couple. That is to say, everything is in its rightful place, ordered and harmonious according to eighteenth-century standards. Wife, dog and nature itself are subservient to the man. While he leans casually on the bench, one hand in his pocket and with his gundog looking obediently up at him, out of deference his young wife is posed a little more formally. The skirts of her pale blue dress are spread out to display the silk. An area of canvas about her lap is unfinished – perhaps intended to hold a pheasant just shot by her husband. To the right the well-ordered fields of their estate roll outwards into the distance. Sheep are neatly enclosed in a far field; corn stooks tidily arranged at the edge of the nearer field.

Later in his career Gainsborough was to receive many portrait commissions from the aristocracy for which he developed a suitably grander style of painting. This couple, painted early in his career, belong to the middle classes. Mr. Andrews's stockings are creased and need pulling up. Nevertheless he and his wife look out with expressions of complete confidence in their place in the scheme of things.

Experiment with the Air Pump

1768

Joseph Wright of Derby

In the seventeenth century the Italian painter Caravaggio (1573–1610) initiated a very influential style of painting sometimes referred to as 'tenebrism', composing his pictures with extreme contrasts of light and shade missing out the middle tones altogether. The effect is very dramatic, even quite theatrical. In eighteenth-century England Joseph Wright of Derby (1734–97) emulated his achievements in works such as this one painted in 1768. The machine which the grey-haired scientist presides over is a vacuum pump and the experiment being conducted is one designed to investigate the properties of air. The condition of the bird in the glass bowl will serve to indicate when all the air has been extracted. The two young girls are fearful of what might happen to it, and one of them hides her eyes. The other man acts as timekeeper while to the left two lovers, utterly engrossed with each other, ignore what is going on. The experiment, however, is no coldly rational product of the Age of Enlightenment. Lit only by the moon and a single candle hidden behind a bowl, this scene rather contains a strong suggestion of magic and witchcraft; the central figure seems closer to a priest than scientist. Reinforcing suggestions of some terrible, sacrificial rite, the strange object kept in the jar in the foreground is probably the lung of a pony.

Constable (1776–1837) was something of a late developer, joining the Royal Academy school in 1799, and first exhibiting there in 1802 and 1803. By 1816 he was financially secure following the death of his father, but only began to win recognition in the 1820s. *The Hay Wain* was first exhibited in London in 1821, under the title *Landscape, Noon*, where it was badly received. Contemporary English taste found the work shocking on account of its bright, fresh colours and thickly applied paint. Constable wanted to abandon the mannered grace and smooth textures of prevailing English landscape painting. He therefore spurned traditional standards of finish, representing sunlight with crude blobs of white or yellow paint in an attempt to describe the changing atmosphere, as here with pools of light forming in the fields as the sun breaks through the clouds. No-one bought the painting until 1824, when it was exhibited to great acclaim in Paris. The French buyer is recorded as saying, 'Look at these English pictures – the very dew is on the ground' Constable himself wrote, 'The sound of water escaping from mill dams, willows, old rotten planks, slimy posts and brickwork, I love such things. These scenes made me a painter.'

The view here is of agricultural worker Willy Lott's cottage on the River Stour in Suffolk, painted from Flatford Mill of which Constable's family had the tenancy. Willy Lott lived there for eighty years – a symbol for Constable of rural continuity and stability. Since its initial success in France, this painting (perhaps more than any other by Constable) has come to define an essential image of the English countryside.

Rain, Steam and Speed –
The Great Western Railway

c. 1844

Joseph Mallord William Turner

At the time this was painted there was evidently a widespread fear that railway travel was seriously bad for the health: it was felt that trains moved so fast that passengers, carried in open-air carriages, might not be able to breathe. Turner's painting, on the other hand, expresses the feeling of exhilaration which this new, modern form of transport excited in the popular imagination. Mechanical, iron-wrought energy is here even equated with the indomitable forces of nature as the locomotive bursts through a small squall, smoke and steam merging indistinguishably with rain and cloud. But for Turner (1775–1851) exhilaration could only exist when mixed with terror. And in this sense, the new source of man-made energy contravened natural law. On the bridge the blurred form of a rabbit or hare can be discerned just in front of the engine's wheels. To the right, down below on the far bank, a horse and plough are seen tilling a field while to the left, two figures fish peacefully from a boat moored in mid-stream. The contrast between old and new is surely deliberate. Rural life as well as traditional forms of labour and leisure are clearly threatened by the infernal power of the train. Equally radical were the means by which Turner chose to express such sentiments with aggressively handled paint.

The Rokeby Venus

c. 1651

Diego Velázquez

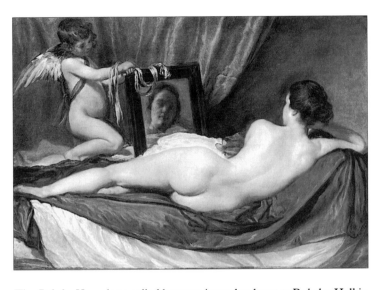

The *Rokeby Venus* is so called because it used to hang at Rokeby Hall in Yorkshire before entering the collection. Venus gazes out at the spectator through a mirror held up for her by her son Cupid. Yet this goddess of love can hardly be said to be seducing the viewer. The reflection of her face is blurred, forestalling any substantial connection between her and us. We are left only with a tantalizing view of her back. Traditionally paintings of Venus reclining show her facing the spectator. It is certain that Velázquez (1599–1660) would have known some of these from the Spanish Royal Collection; he was court painter to Philip IV of Spain. His subversion of this tradition may therefore be seen as deliberate. It is possible, however, that this painting started out simply as a nude woman rather than Venus herself. A small strip of canvas about four inches wide has been added across the top; the horizontal join is still visible and passes through the forehead of Cupid. This addition suggests that the Cupid might only have been added later once the nude had already been finished, thereby transforming a naked woman into a mythological goddess. Looking closely at the painting it is fascinating to see how Velázquez varies the textures of his paint. Thin and fluid in the draperies, it is more opaque in the flesh which nevertheless reflects some of the cold blue-grey of the satin. Earlier this century the painting was slashed by a suffragette in protest against the lack of votes for women. The marks on Venus's back are still faintly visible.

Umbrellas

1881–84

Pierre-Auguste
Renoir

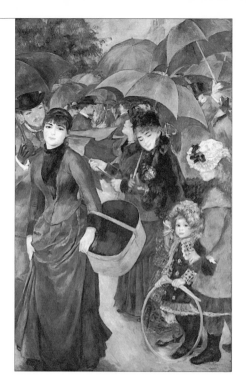

People almost always seem to be flirting in Renoir's paintings. He seems particularly to have enjoyed offering the spectator views of easy, uncomplicated, and festive interchange between the sexes. Here, the young woman on the left carrying a basket is about to be propositioned by the gloved, top-hatted gentleman who is hovering over her shoulder. Her wistful expression suggests that this time his advances may well not be successful. Unusually, the weather is overcast. Renoir (1841–1919) normally preferred to depict his sexual struggles taking place beneath sunny skies. Yet although the sky here is grey and it has just started to rain, his palette is orientated more towards blue than black or grey. In other words, even on the dullest of days Renoir looked for colour. Likewise, even though everyone here sports an identical type of umbrella, Renoir still chooses to describe individual personalities. This is no anonymous, homogenous city crowd; rather, within the uniformity, Renoir finds and enjoys telling a specific story. There is however a noticeable discrepancy in style within this painting. For example, the young woman on the left is sharply drawn while the two girls on the right, who were probably painted first, are described with a softer, more blurred touch. At this point in his career Renoir was consciously trying to tighten up what he felt were the more untidy and disorganized aspects of his earlier Impressionist paintings – in particular their looser, more instinctive type of brushwork.

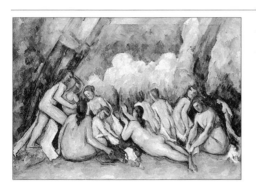

Une Baignade, Asnières was the first major painting Seurat (1859–91) completed. In this work he seems to have set about tidying up or restructuring the more instinctive spontaneity of Impressionist art. For example, contrary to Impressionist practice, *Une Baignade* (which means 'bathing place') was not painted from life but was born in the studio after lengthy preparation. The subject matter, though, is certainly Impressionist. Asnières was a popular bathing resort on the Seine outside Paris, and many of the Impressionists had painted there in previous years. Here, factory workers bask motionless in the sun while a ferryman rows a bourgeois couple across the river to the more fashionable island of La Grande Jatte. But all seems timeless, silent and solemn. The principal figures seem depersonalized. All except one face the same way, and all are in profile.

Large Bathers

1900–05

Paul Cézanne

There was uproar when this painting was first hung in the National Gallery earlier this century. The painting seemed (and is by certain standards) unfinished yet Cézanne's subject, nude 'bathers' enjoying a sunny picnic, is one of the most venerated in the history of European painting. Cézanne (1839–1906) seemed to be attacking a cherished tradition. The subject, however, stands as a symbol for an earthly paradise – these 'bathers' do not have to work for a living, and it is always sunny. Cézanne's sketchy technique was designed to suggest immediacy and proximity, as if this were a scene he had painted from life rather than from the imagination. His method of describing shadows with colour, as opposed to grey or black, was also intended to communicate a feeling of well-being in the spectator, and to lend a warm glow to this vision of a pastoral idyll.

Address
Romney Road, Greenwich,
London SE10 9NF
© 081 293 9618

Map reference
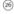
㉖

How to get there
Maze Hill Station (BR);
Surrey Docks underground
then bus 108b, 188. Buses:
53, 54, 75, 177, 180, 185.
Boats from Westminster,
Charing Cross, Tower Bridge.

Opening times
1 April to 30 Sept: Mon–Sat,
10–6; Sun, 12–6. 1 Oct to 31
March: Mon to Sat, 10–5;
Sun, 2–5.

Entrance fee
£7.95. £3.95 single site
ticket. Discounts for
students, pensioners and
families. Tickets give
admission to Queen's
House, Royal Observatory
and Cutty Sark.

The National Maritime Museum stands on the site of Bella Court, built between 1426 and 1434 by the Duke of Gloucester, which became a favourite Tudor royal residence known as Palace Placentia. Henry VIII and his daughters Elizabeth and Mary were born here, and it was here that Edward VI died. It was also at Placentia that Sir Walter Raleigh placed his cloak over a puddle for Elizabeth I to walk upon. During the Commonwealth, the Parliamentarians tried to sell it without success and the palace was stripped of furniture and used as a biscuit factory. It was then demolished by Charles II who commissioned John Webb to build him a new palace.

Webb was the nephew of Inigo Jones, who had just built the Queen's House nearby; he based his design on drawings made by his uncle. The foundation stone was laid in 1660 but the project was abandoned unfinished. Subsequently, in the reign of William and Mary, Webb's incomplete building was added to by Sir Christopher Wren (who did not charge for his services) to found a hospital for Seamen, in imitation of the recently opened Royal Hospital in Chelsea; he was assisted by Hawksmoor and Vanbrugh. Wren's design forms two symmetrical blocks that frame Inigo Jones's Queen's House, apparently because Queen Mary insisted that the Queen's House remain visible from the river. Later in the eighteenth century Samuel Johnson described the layout as 'too much detached to make one great whole'. In 1873 the concept of a hospital was rejected in favour of a pension system and the buildings were given over to the Royal Naval College. The present museum opened to the public in 1937. Its permanent collection, which is concerned with seafaring and contains a number of fine marine paintings, is housed in the West wing, while the East wing is used for temporary exhibitions.

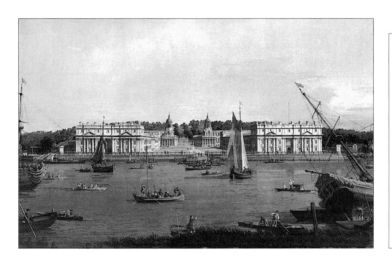

Canaletto (1697–1768) arrived in London in 1746, and remained there on and off for ten years. War in Italy and Austria had curtailed the numbers of English visitors to Venice on the Grand Tour, and hence a vital source of patronage, so Canaletto decided to come to London himself and find work. It is not known who, if anyone, commissioned this picture. It is possible that Canaletto painted it without a buyer but in the hope of attracting a patron. Lit from the right, the cool greys of the buildings stand out clearly from the green grass and blue sky. Figures provide tiny accents of blue, red and yellow. For all its topographical accuracy, however, Canaletto has bathed this view of London in pristine Venetian sunshine. And in order to further enhance the painting he has combined two viewpoints, about ten degrees apart, so as to create an artificially wide angle of vision. But despite these visual enticements, demand for his work had declined by 1750: in London (as opposed to Venice) his subjects could only ever be topographical rather than evocative or romantic (as were his Venetian works when seen through English eyes). Taste underwent a change with the popularity of Hogarth's satirical scenes of London street life, which acted as a corrective to Canaletto's scrubbed and manicured version of the city.

Built 1616–37

Built as a summer residence for Anne of Denmark by James I, the Queen's House was designed by Inigo Jones. It was begun in 1616 and finished in 1637 for Henrietta Maria (wife of Charles I) from whom it takes its name. Jones had been to Rome in 1614 but rejected the ornate facades he had seen on palaces there, keeping the exteriors plain and sober – 'sollid, proporsionable according to the rulles, masculine and unaffected' as he said himself. The rules he mentions were those particularly of the villas by Palladio, whose harmoniously ordered architecture the Queen's House consciously emulates. It was in fact the first Palladian house to be built in England and must have looked terribly new when completed and before it was dwarfed by Wren's flanking blocks. Queen Anne had ordered a house in two parts – one, to the north, was within the palace precincts and is fronted with a terrace; the other, to the south, was within the public park and is faced with a loggia of Ionic columns. The two halves were joined by a bridge which spanned a public road, but were connected in the 1660s when additional space was required. The house has recently, and not uncontroversially, been restored. It contains a number of fine paintings by Lely in the Queen's Presence Chamber and a portrait of Inigo Jones by Hogarth in the Queen's Ante Chamber.

The National Portrait Gallery was founded in 1856 to display portraits of distinguished men and women from British history, presumably so as to offer up examples for us all to emulate but also, more importantly, to create an immediate and intimate survey of British history. Figures from the monarchy, politics, the arts and sciences, sport, society, and industry are all represented. Both the works and the rooms are well labelled, making the museum an invaluable and lively place from which to study the past. The collection now comprises over 10,000 portraits in all media – oil paintings, watercolours, drawings, miniatures, sculpture, caricatures, silhouettes, photographs and video, and it continues to grow. Acquisitions to the collection were and continue to be chosen according to historical rather than aesthetic criteria so that not all the works on view are necessarily of the highest artistic quality. For example, the group portrait of the Brontë sisters, the novelists Anne, Emily and Charlotte, painted by their brother Branwell is from an artistic point of view hopelessly naïve and also terribly badly damaged. But its power lies in its directness of approach.

New galleries housing the twentieth-century collections have recently been opened; temporary exhibitions are also held in these rooms. The museum first opened in modest premises in Westminster, then moved to South Kensington, then to Bethnal Green (now the Museum of Childhood). The present building, designed in a Romanesque style, was donated by William Henry Alexander and opened to the public in 1896. Only a small proportion of the collection is on show at any one time, at present something like ten per cent of the total, though works not on display can usually be seen by arrangement. The museum also looks after an enormous archive and library, housed in separate premises, for which permission is needed to visit.

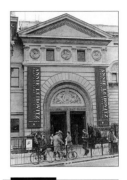

Address
2 St Martin's Place, London
WC2H 0HE
℅ 071 306 0055

Map reference
㉗

How to get there
Charing Cross or Leicester Square underground.
Buses: 1, 3, 6, 9, 11, 12, 13, 15, 15a, 24, 29, 53, 77, 77a, 88, 159, 168, 170, 176, 177, 184, 199.

Opening times
Mon to Sat, 10–6; Sun, 2–6; closed 24, 25 & 26 Dec, Good Friday, May Bank Holiday.

Entrance fee
Admission is free.

Tours
An active education programme including public lectures.

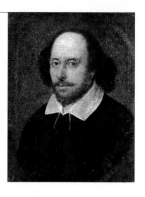

William Shakespeare

c. 1610

John Taylor,
attributed

This was the first portrait to be acquired by the gallery, as a gift from the first Earl of Ellesmere in 1856. It is known as the *Chandos Portrait* having once belonged to the Duke of Chandos during the eighteenth century, though it also seems to have belonged at one point to the writer Sir William Davenant (1606–68). Its importance derives not from its aesthetic value so much as the fact that it is the only known contemporary portrait of the greatest figure in English literature, and so quite possibly a reasonably accurate likeness of the man, unlike the many fanciful images of him that were created after his lifetime. Nonetheless, it seems strangely disconcerting to be confronted with the individual human features of a man most justly and famously known for his words. But Shakespeare himself said that his immortality would come through his verse.

George Gordon, Sixth Lord Byron

c. 1835

Thomas Phillips

The portrait shows Byron (1788–1824), the infamous poet and libertarian, dressed in Albanian costume aged about twenty-five. The original, of which this is a later copy, hangs in the British Embassy in Athens and was painted in 1813. Byron sat for the portrait by Thomas Phillips (1770-1845) at the request of his publisher John Murray shortly after the publication of the first part of the poem *Childe Harolde's Pilgrimage* and his own return from travels in the Levant. He spent time in Italy writing radical political tracts with fellow poet Percy Bysshe Shelley before eventually continuing to Greece where he joined in the War of Independence. Although he financed his own brigade of troops for the Greek cause – his personal bodyguards wore the Albanian national costume he sports in this portrait – Byron himself never saw serious action. He died of fever in March 1824.

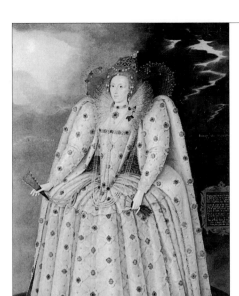

This likeness of Elizabeth I (1533–1603) is known as the *Ditchley Portrait* because it was painted in commemoration of her visit to Ditchley Park near Oxford, the home of Sir Henry Lee (1533–1611). As the Queen's Champion, Lee organized official jousts and tournaments in which he defended Elizabeth's honour. He stepped down from the post in 1590 and incurred her displeasure by retiring to his seat in Oxford to live with his mistress. Elizabeth visited Ditchley in 1592 as a sign of her forgiveness, on which occasion Lee commissioned Gheeraerts (1561-1635) to paint this portrait. The theme of forgiveness pervades the work. Elizabeth is shown driving away the clouds with her hand, ushering in sunny weather. Forgiveness is also the message of the inscriptions and sonnet, incomplete now because the portrait was cut in the eighteenth century.

The portrait is a flattering one: Elizabeth displays the elegant hands of which she was evidently so proud. But she also stands on a map of England at the top of a globe, her feet significantly over Oxford. The conceit here is that she is ruler of the world, something also referred to in the spherical earring and her control over the weather. She wears a white dress studded with pearls and coral, all of which refer to her purity. Elizabeth deliberately promoted an image of herself as the 'Virgin Queen', a monarch married only to her country and her subjects' welfare. Nearly sixty when the portrait was made, she was no longer young. Contemporary accounts record how thin she was, that her hair had begun to fall out and that she suffered from appallingly bad breath. Apparently she complained that Gheeraerts had made her look like an old woman. All of the many copies made of this portrait depict her as much younger.

Remodelled 1756-79

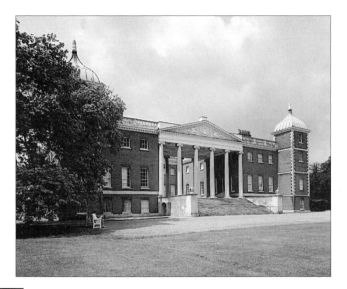

Address
Isleworth, Middlesex TW7 4RB.
✆ 081 560 3918

Map reference

How to get there
Osterley underground.
Buses: H91, 116; Green Line buses 704, 705.

Opening times
1 April to 31 Oct: Wed to Sat, 1–5; Sun, 11–5; closed Nov to March.

Entrance fee
£3.50. Discounts for children.

Tours
Guided tours by arrangement.

Osterley Park House, in origin a sixteenth-century country house, was bought early in the eighteenth century by Francis Child, founder of Child's Bank. His grandson employed Sir William Chambers (1723–96), tutor in architecture to the Prince of Wales, later George III, and architect of Somerset House, to remodel it. With the Gallery and the Breakfast Room completed, the work was taken over in 1762 by Robert Adam (1728–92), Chambers's principal rival. Adam remained faithful to the original plans but added the distinctive portico in the façade and designed most of the interior decoration. The house remains outstanding as an example of Adam's work – especially the plasterwork on the library ceiling and the Drawing Room – of which Horace Walpole wrote in 1773 that it was 'worthy of Eve before the Fall'. The house also contains superb examples of Adam's furniture, in particular the domed bed in the State Bedchamber. Altogether the house offers one of the best preserved and most comprehensive visions of eighteenth-century magnificence.

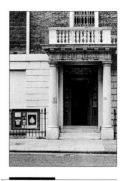

This small museum is entirely devoted to Chinese ceramics. The collection was presented to the University of London in 1951 by the scholar Sir Percival David (1892–1964) and supplemented the following year by a donation from the collection of the Hon. Mountstuart W. Elphinstone. Its only rival is that of the former Imperial Collection, now in Taiwan. Sir Percival deliberately collected within prescribed limits: the ceramics on display range from the tenth to the eighteenth centuries. They are arranged chronologically on three floors; the collection is particularly strong in ceramics from the Ming Dynasty (1368–1644). Many of the pieces are marked or inscribed with the Imperial seal, proof that they once belonged to the Imperial Collection. As such, some of them are of exceptional historical as well as artistic value.

Of particular interest are an early sixteenth-century table screen with blue decoration which contains an inscription from the Koran, and was probably made for the Moslem eunuchs who became highly influential at the Chinese court; a Guan ware bottle vase from the thirteenth-century with blue-grey glaze and intentional cracks which follow the stress lines of the thrown shape; and a twelfth-century Ding ware bowl with moulded decoration which contains an inscription by the Emperor who had the piece in the eighteenth century and wanted to record his appreciation for posterity.

Address

53 Gordon Square, London WC1H OPD

 071 387 3909

Map reference

㉙

How to get there

Russell Square or Euston Square underground.

Buses: 7, 8, 10, 14, 18, 19, 24, 25, 27, 29, 30, 38, 55, 68, 73, 134, 135, 168, 170, 176, 188, 239, 253.

Opening times

Mon to Fri, 10.30–5. Closed on weekends and Bank Holidays.

Entrance fee

Admission is free.

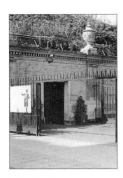

Address
Buckingham Palace Road,
London SW1A 1AA
✆ 071 493 3175

Map reference
㉚

How to get there
Victoria underground.
Buses: 2, 2b, 10, 11, 16, 24,
25, 29, 36, 36a, 38, 39, 52,
55, 70, 76, 149, 185, 500,
507.

Opening times
4 March–22 Dec: Tues to
Sat 10-5, Sun 2–5. Bank
holidays 10–5. Closed
during Jan and Feb and on
Mon, 24 & 25 Dec, Good
Friday. The gallery is open
daily while Buckingham
Palace is open (7 Aug to 2
Oct).

Entrance fee
£3.00. Discounts for
children and pensioners.
Family tickets £7.50.
Combined ticket for Gallery
and Royal Mews £5.

During World War Two a bomb destroyed part of the western wing of Buckingham Palace, which had been converted by Queen Victoria early in her reign for use as a private chapel. At the instigation of the present Queen and the Duke of Edinburgh the ruined chapel was converted into a small gallery at which temporary exhibitions of works of art from the Royal Collection might be shown to the public. The Queen's Gallery opened in 1962.

The Royal Collection of paintings, sculpture and the decorative arts has few rivals. It is also enormous, so the exhibitions mounted here only show very small numbers of works devoted to a particular theme or subject. This is not such a grave drawback since everything on show is of the most superb quality and it is worth seeing whatever is on display. The exhibitions are also usually accompanied by excellent catalogues. Not every British monarch has been enamoured of the arts, and the collection is largely the result of the efforts of a few great connoisseurs – Charles I, Frederick Prince of Wales and George I in particular, as well as Charles II, George III and Prince Albert. The collection of works by Van Dyck, Canaletto, Stubbs and Gainsborough is unequalled by any other in the world. There are also exquisite examples of paintings by Holbein, Raphael, Jan and Pieter Bruegel, Rembrandt, Hals, Claude and Rubens, to name but a few. Do not be put off by the rather modest and unprepossessing entrance.

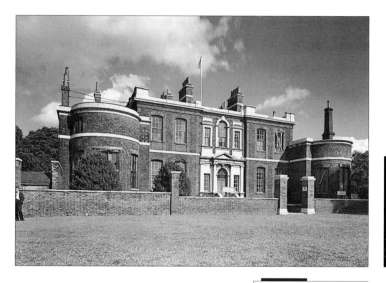

The Ranger's House is so called because it was inhabited from 1814 by Princess Sophia Matilda, daughter of George III, in her official capacity as Ranger of Greenwich Park – in fact the post was a sinecure and the dwelling a 'grace and favour' apartment. The core of the house was built around 1700 for Captain Sir Francis Hosier, a successful naval officer and entrepreneur. It then passed to the Fourth Earl of Chesterfield (1694–1733) who added the South wing (designed by Isaac Ware and completed in 1750). The North wing was added later in the eighteenth century. It now contains the Suffolk collection of paintings, put together by the Earls of Suffolk. This comprises fifty-three paintings, and is especially rich in seventeenth-century English portraits. Amongst these is the celebrated *Berkshire Marriage Set*, a series of seven female portraits by William Larkin. There are also a number of portraits by Sir Peter Lely, including a rather erotic one of Mary of Modena, James II's second wife. Prior to becoming a museum, the house served as a tea room for people using the park. None of the furnishings survive, though the panelling is original.

Address
Chesterfield Walk,
Blackheath, London
SE10 8QX
✆ 081 853 0035

Map reference
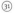

How to get there
New Cross underground, then bus 53. Blackheath or Maze Hill Stations (BR). Buses: 53, 54

Opening times
Daily 10–1; 2–6 (1 Oct to 1 April 10–1; 2–4); closed 24 & 25 Dec, Good Friday.

Entrance fee
£2.00. Discounts for children, students and pensioners.

Anne Cecil Countess of Stamford

c. 1614

William Larkin
(attributed)

Anne Cecil wears a slashed silk dress, highly fashionable in court circles at the time. Her sister Diana, also portrayed in the *Berkshire Marriage Set*, wears an identical one. Portraits by Larkin (d.1619) are distinguished by their brilliant colouring and the detailed observation of costumes and fabrics. Recent cleaning has restored much of the colours' brightness, though certain areas have suffered permanently. Blues have faded to grey, greens to brown – in their prime they would have been even more dazzling. Larkin's work is rare, and this set of portraits is the finest group anywhere in the world. His style is so meticulous it is as if each stitch has been painted. It is also highly artificial – there are, for example, almost no shadows falling across the fabrics and draperies. The face, however, is well modelled. This colourful, detailed technique must have appealed to Larkin's sitters not only because he could capture a likeness but also because of the portraits' arresting decorative impact. Yet just over ten years after his death Anthony van Dyck's arrival in England as court painter to Charles I was to completely change the conventions of English portraiture. This is well illustrated in a portrait of Lady Anne's sister Diana Cecil, made twenty years later, when she was Duchess of Elgin. The painting is by Cornelius Johnson – one of many imitators of Van Dyck's more informal and painterly style. The differences in style between the two portraits could hardly be greater.

The Royal Academy was founded in 1768, with Sir Joshua Reynolds as its first president. It was established to provide a free school for young artists and to give older ones a forum to exhibit and sell their work. The Academy still runs an art school and holds an annual show of contemporary works every summer from June to August. This is something of a national institution and is very popular, though the works are usually somewhat conservative. The Royal Academy is administered by fifty elected members called Royal Academicians, each of whom has to donate an example of his or her work. Hence the institution owns a fascinating collection of British painting and sculpture. Although most is not on show (though it can be seen by appointment) some of it is displayed in the present building, Burlington House.

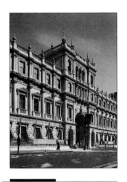

This was originally a seventeenth-century house remodelled by Colen Campbell for the Third Earl of Burlington. Wings to the west, south and east were added in the nineteenth century by Banks and Barry. Between 1872 and 1874 Sydney Smirke altered the original house for use by the Academy, adding a second storey to the facade with statues of Phidias, Leonardo, Flaxman, Raphael, Michelangelo, Titian, Reynolds, Wren and William of Wyckeham as well as the rusticated arcade and the exhibition galleries. Exhibition space has now been further extended with the opening of the modern Sackler Galleries, designed by Norman Foster in 1991. The Royal Academy is now one of the primary venues for loan exhibitions in London, fulfilling a function which the National and Tate Galleries are unable to perform by themselves due to lack of space. It mounts numerous important and internationally renowned shows each year.

Address
Burlington House, Piccadilly, London W1V 0DS
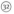 071 439 7438

Map reference
(32)

How to get there
Green Park or Piccadilly underground. Buses: 9, 14, 19, 22, 38.

Opening times
Daily 10–6, last admission 5.30. Closed on 24, 25 & 26 Dec, Good Friday.

Entrance fee
Varies according to the exhibition on show.

Tours
Guided tours of the building available.

Taddei Tondo (Madonna and Child with the Infant St John)

1504–05

Michelangelo Buonarroti

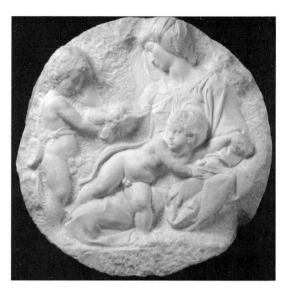

Soon after he had finished the sculpture of *David* – and with it established his reputation as the leading sculptor of his day – Michelangelo (1475–1564) carved this relief from the finest Carrara marble. The *tondo* (the word means a painting or relief of circular shape) was commissioned by Taddeo Taddei, a Florentine in whose family it remained until the nineteenth century. It was then sold to a French collector, and subsequently to the landscape artist Sir George Beaumont, who played an instrumental role in the foundation of the National Gallery. His widow bequeathed it to the Royal Academy in 1830. The tondo is one of the Royal Academy's greatest treasures, and it can be seen near the entrance to the Sackler Galleries. Playful and intimate in character, it shows the Christ child shying away from John the Baptist, seeking protection in the skirts of the Virgin Mary. John is holding out a bird to him, traditionally a goldfinch. This bird has a red spot on its breast which, according to medieval legend, it acquired at the moment it flew over Christ's head on the road to Calvary. As it drew a thorn from the crown on His brow it was splashed with a drop of His blood. John is thus presenting Christ with a symbol of his own destiny, one which he is for the moment reluctant to embrace. The informality of the scene is enhanced by the rough, unpolished marble in the background.

Built 1682–92

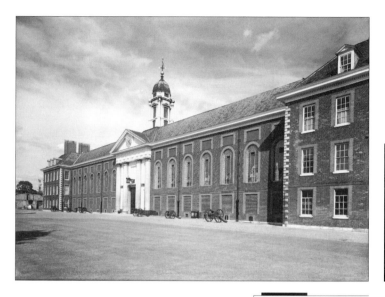

On the site of an unsuccessful theological college founded by James I, Charles II built the Royal Hospital. It was and still is a home for old soldiers, known as Chelsea pensioners, who are very distinctive in their blue or red uniforms. The buildings were designed by Sir Christopher Wren and built between 1682 and 1692. The central block, with its porticoed entrance of plain Tuscan columns, is both handsome and sober. It contains the Great Hall (right) and the Chapel (left) with the pensioners' dormitories in the wings. The Chapel contains a fine painting in the apse above the altar by Sebastiano Ricci. The carved wooden bosses on the ceiling are all different. In the Great Hall hang captured enemy flags. A small museum is housed in the left wing in the Secretary's Office. In the middle of the central court is a statue of Charles II by Grinling Gibbons, which is wreathed in oak leaves each year on Founder's Day. The grounds beyond sweep dramatically down to the Embankment.

Address
Royal Hospital Road,
London SW3 4SR
℡ 071 730 0161

Map reference
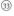

How to get there
Sloane Square
underground. Buses: 11, 39,
137, 137a, 211.

Opening times
Mon to Sat, 10–12 and 2–4;
Sun, 2–4. The museum is
closed on Sun from Sept to
April and on Bank Holidays.
The grounds are open on
weekdays, 10–dusk, and on
Sun, 2–dusk.

Entrance fee
Admission is free.

St Bartholomew-the-Great

Begun 1123

Address
West Smithfield, London
EC1
✆ 071 606 5171

Map reference
(34)

How to get there
Barbican and St. Paul's
underground. Buses: 4, 8,
56, 22b, 25.

Opening times
Daily, 8.30–4.30 (from mid-
Nov to mid-March until 4);
Sat, 10–4; Sun 2–6.

Tours
Tours can be arranged in
advance.

The priory church of St. Bartholomew-the-Great is the oldest surviving church in London. It was founded in 1123, along with the nearby St. Bartholomew's Hospital, by an Augustinian monk named Rahere, formerly a member of Henry I's court. Over time it became the largest monastery in London. Rahere's tomb can be found on the north (left) side of the altar, more or less opposite Prior Bolton's window. This was put in by a later Prior so that he could oversee the monks at their worship. What survives today is roughly half of the original twelfth-century structure (with sturdy round Norman arches), which was repaired in the fifteenth century and given Gothic or pointed arches. The nave was destroyed during the Dissolution of the Monasteries in the 1540s, and the church abandoned. It was saved from complete ruin only in the late nineteenth century. The church bells are almost the only ones in the country to have survived the Reformation. The painter William Hogarth was baptized here in the eighteenth century.

**Built
1675–1710**

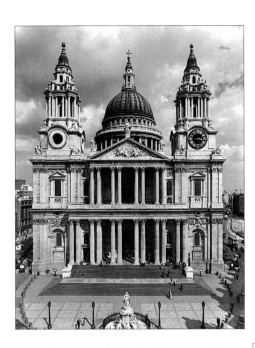

There has been a Christian shrine on this site since at least 604 AD when a wooden Saxon church stood here. This burned down in 1087 and a massive Norman cathedral built of stone was begun immediately afterwards. This was dedicated in 1241, but reworking in the Gothic style only finished in 1347. In the seventeenth century Inigo Jones added a portico to the West front and recased the nave with Corinthian columns fifty feet high. This was the building which perished in the Great Fire of 1666.

Christopher Wren was appointed architect to rebuild the cathedral, a project that was financed by a tax on coal. The present St. Paul's is his masterpiece – a majestic Baroque ark perched on the top of Ludgate Hill dominating the city. In many ways it stands as a Protestant rival to St. Peter's in Rome. Though where the true scale of St. Peter's is somewhat hidden behind the facade, St. Paul's impresses most from the outside. The interior, by comparison, seems a little narrow and cramped.

Address
St. Paul's Churchyard,
London EC4M 8AD
✆ 071 236 4128

Map reference

How to get there
Mansion House or St Paul's underground. Buses: 4, 9, 22b, 26.

Opening times
Mon to Sat, 8.30–4; Sunday services.

Tours
Guided tours at 11, 11.30, 1.30 and 2.

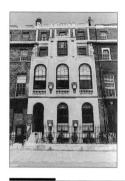

Address
13 Lincoln's Inn Fields,
London WC2A 3BP
 071 430 0175

Map reference
㊱

How to get there
Holborn underground.
Buses: 8, 22, 22a 25, 68,
168, 188, 501, 505, 523.

Opening times
Tues to Sat, 10–5; closed
Sun, Mon and Bank
Holidays. Late evening
opening 6–9 first Tue of
each month.

Entrance fee
Admission is free

Tours
Lecture tour on Sat at 2.30.
Places limited – tickets
available at 2.

This incredibly varied and idiosyncratic museum was bequeathed to the nation by Sir John Soane (1753–1837). Soane was the architect of the Bank of England and the Dulwich Picture Gallery, though most of his other important buildings do not survive. He was also Professor of Architecture at the Royal Academy. His collection was housed at his own home in Lincoln's Inn but he also made it available to his students. It fully illustrates his belief that 'Architecture is the Queen of the Fine Arts … Painting and Sculpture are her handmaids, assisted by whom … she combines and displays all the mighty powers of Music, Poetry and Allegory.'

Once he had inherited private means in 1792, Soane collected avidly and eclectically: Classical, Egyptian and Chinese antiquities, gems, bronzes, casts and paintings. The collection also included 30,000 architectural drawings, 150 models and a library of 8000 volumes. Note especially the bird's eye perspective drawing of the Bank of England, cut away as if it were a Roman ruin (North Drawing Room), the fine oils by Canaletto and Turner (New Picture Room), the Piranesi prints (Picture Room) and a capital from the interior of the Pantheon in Rome. Equally fascinating is the architecture of the house itself – actually three houses, nos. 12, 13 and 14, which Soane combined and substantially altered. On the exterior the smooth classical front was designed by Soane himself. Unusual changes of level, and an imaginative use of mirrors help to create a maze-like effect in the small, crowded rooms. The collection is displayed strictly as Soane wished. In the Picture Room, he brilliantly solved the problem of a lack of hanging space: three of the walls open like cupboards to reveal hinged panels which are hung with pictures on both sides. This is where his two sets of paintings by Hogarth are displayed, *The Rake's Progress* and the *Election*.

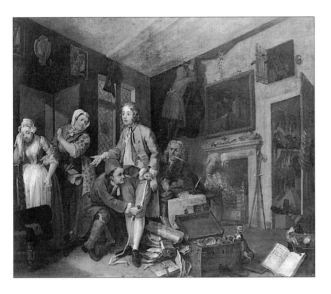

The immense popularity and success of Hogarth (1697-1764) was spread by the engravings made after his series of moral paintings, of which *The Rake's Progress* is one. It depicts, in eight separate works, the downfall of a dissolute young man, Tom Rakewell, as he squanders the fortune he has inherited from his father. He is shown surrounded by his new retinue of servants; at an orgy held in a notorious coffee house in Covent Garden; being arrested for debt; marrying an old hag for her money; losing a second fortune gambling at White's Club in Pall Mall; imprisoned for debt; and finally languishing in the Bedlam hospital for the insane. The first scene, *The Heir*, illustrated here, shows him having just inherited his first fortune. While he is being measured for a new suit, a mother demands that he marry her daughter, who is clearly pregnant. Tom is trying to buy them off while a lawyer helps himself to his gold. The many other details – such as the starved cat, the coat of arms, the shoe mended with a bit of a Bible and the hidden gold – describe the miserly and avaricious nature of the now departed father. Hogarth's series were disapproved of by the aristrocracy but actually appealed to a newly emerging and increasingly influential bourgeois class of patrons, which was only then in the process of forming a code of behaviour for itself. Hence the popularity of the artist's critical and combative satires on the human and social animal.

Built 1756–66

Address
27 St James's Place, London
SW1 1NR
✆ 071 499 8620 (Tue to Fri,
10–1)

Map reference
㊲

How to get there
Green Park underground.
Buses: 9, 14, 19, 22, 25, 38.

Opening times
Sun only, 11.30–5.30
(except Aug and Jan).
Last admission 4.45.

Entrance fee
£6.00. Discounts for
children, students and
pensioners.

Tours
Tours every 15 minutes.

A few years ago Spencer House was spectacularly rescued from slow death by Baron Rothschild. Previously divided into drab offices, it has since been restored to its original grandeur. It was built between 1756 and 1766 by the First Earl of Spencer, and is probably the finest eighteenth-century town house in London as well as one of very few to remain intact in the hands of its original owners. The building itself and lower floors were designed by John Vardy, a pupil of William Kent and an architect of the Roman style of classicism advocated by Palladio. He was then replaced by James 'Athenian' Stuart who designed the interior decoration of the upper rooms in the new Neoclassical style, based on Greek Classical types. Nine State Rooms are open to the public – of particular brilliance are Vardy's Palm Room on the lower floor and Stuart's Painted Room upstairs. Paintings and furniture have been loaned by the Victoria and Albert Museum, the Royal Collection and Kenwood House to complete the effect.

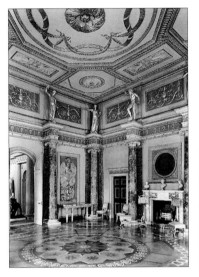

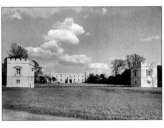

Syon House is the seat of the Dukes of Northumberland, built on the site of a convent founded by Henry v but given to the Percy family following the dissolution of the monasteries in the sixteenth century. Robert Adam was commissioned to remodel the interiors in 1761. It is for these rooms and the collection of historical British portraits, as well as for the grounds laid out by 'Capability' Brown, that the house is justly famous. The somewhat stark exterior bears no indication of the riches inside. The plain Hall with black and white marble floor contains copies of famous antique statues including *The Dying Gaul*, cast in Rome in 1773 for £300, and a copy of the *Apollo Belvedere*. Past the Pillar or Ante Room and the Dining Room is the Red Drawing Room containing magnificent Adam furniture. Among the portraits here is one painted by Lely in 1647 showing Charles I with his son James, Duke of York. The portrait was done when the King, who was in custody at Hampton Court two years before his execution by order of Parliament, was allowed out to go and visit his children at Syon.

Address
Brentford, Middlesex
TW8 8JF
✆ 081 560 0881

Map reference
㊳

How to get there
Gunnersbury underground; Kew Bridge Station (BR). Buses 37, 117, 203, 237, 267, E1, E2.

Opening times
House: 1 April to 30 Sept, Weds to Suns, 11–5; Octs, Suns only, 11–5. Closed Nov-March. Gardens: daily 10–6; Nov to Feb, daily 10–dusk.

Entrance fee
£3.25 for house; £2.25 for garden; £4.75 for both.

93

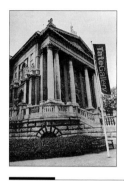

Address
Millbank, London
SW1P 4RG
✆ 071 887 8000
for recorded information:
✆ 071 887 8008

Map reference

How to get there
Pimlico underground.
Buses: 2, 3, C10, 36, 77a,
88, 159, 185, 507.

Opening times
Mon to Sat, 10–5.50; Sun,
2–5.50; closed on 24, 25 &
26 Dec, 1 Jan, Good Friday
and May Bank Holiday.

Entrance fee
Admission is free. A charge
will normally be made for
temporary loan exhibitions.

Tours
Lectures, room talks, films.
Lecture tours for groups
may be booked in advance.

The Neoclassical building by Sidney J.R. Smith opened to the public in 1897. The building and part of the collection of Victorian art were given to the nation by Sir Henry Tate (1819–99), who made his fortune from sugar cubes. The gallery was originally intended to provide a national museum of British art, for although the National Gallery housed a number of works by British artists it was soon realized that there simply was not enough space to contain sufficent numbers. Also the National Gallery did not house works by living artists.

Following the bequest in 1916 of French Impressionist paintings from the collection of Sir Hugh Lane, the Tate now houses both the national collection of British paintings, and British and foreign modern painting and sculpture from the late nineteenth century to the present day. It is a very wide brief and patently too much for a building of its size, so that only a small fraction of the collection can be shown at any one time. There is talk of creating a new museum for the modern and contemporary collections, leaving the Tate as a national museum of British art. Meanwhile, in recent years, one way of remedying the situation has been to rehang the collection on a much more regular basis than before. The 'new hang' has very largely been deemed a success. However, since works are transferred from store to the galleries so often, there is no guarantee that the works described below will all be on show at any one time. The Tate has the further responsibility of housing the Turner Bequest, a donation of 300 oils and 19,000 watercolours by the artist which he left to the nation in his will. These are now displayed in the Clore Gallery, a purpose-built extension to the east which was designed by James Stirling and which opened in 1987. Other Tate Galleries have been established in Liverpool, and in St Ives in Cornwall.

The innovations of European Renaissance painters arrived late in England. At the beginning of the seventeenth century a painting such as this would have been unspeakably unfashionable on the continent. Holbein had already introduced Henry VIII's court to the techniques of perspective and the subtleties of modelling with light and shade early in the sixteenth century – almost one hundred years after they had been pioneered in Italy. This portrait, painted about fifty years after Holbein's death, remains almost totally unaffected by such skills. By the later sixteenth century there was a return to older styles based on heraldic repetition and emblematic pattern. This approach was favoured by Elizabeth I (1533–1603), and the anonymous artist who painted this double portrait of two ladies from the Cholmondely family adhered to this fashion. He had good reasons for doing so apart from royal injunctions against Renaissance realism. The inscription on the painting tells us that the sitters were '…born the same day, Married the same day And Brought to Bed the same day' – a pattern of repetition that makes the naïve style wholly appropriate. Despite this, it should be noted that the artist was able to describe subtle differences in these two sitters' faces – one appears to have a less severe character than the other. The babies are wearing christening robes. Twenty years or so after this painting was made King Charles I invited the Flemish artist Anthony van Dyck to England as court painter. Under his influence English portraiture irrevocably embraced European manners.

Hogarth's Servants

c. 1750–55

William Hogarth

Hogarth (1697–1764) was an aggressively self-confident man. Proudly nationalistic and fiercely critical of the prevailing Rococo taste on the Continent, he was also endowed with a robust humanity. This last quality is very evident in this group portrait, which expresses warmth without sentimentality. He was trained as an engraver and no record exists of any painting made before he was thirty. The portrait of his servants is an unusually private painting for a man better known for his more public series paintings, though it may have hung in his studio as an example to potential sitters of his skill as a portraitist. In any case, the likenesses seem vivid and fresh. Hogarth was evidently well-loved by those in his employment who tended to stay in his service for many years.

Mares and Foals

c. 1760–70

George Stubbs

Stubbs (1724–1806) was almost entirely self-taught. Born in Liverpool he settled in London in 1756. He made his reputation with the publication of *The Anatomy of the Horse* three years later. This book of etchings which Stubbs engraved himself from his own drawings was the product of ten years of work; it is still referred to by veterinary surgeons. On the strength of this achievement Stubbs embarked on a highly successful career as a horse painter. This painting displays a masterful combination of convincing representation and harmonious composition – the arrangement of the horses' necks and heads in one continuous, flowing movement is especially satisfying. Nor is the landscape, positioned low down in the composition and painted in subdued tones, permitted to distract attention.

Blake (1757–1827) enjoyed little material success until, towards the end of his life, he found a steady source of patronage and was hailed as a leader by a group of younger artists. He was a philosopher and a poet as well as a painter, but was always too idiosyncratic a visionary to appeal to a wide audience. Blake was among the first to react against the prevailing rationalist philosophy of the eighteenth century. Reason, he argued, was only one of a number of different elements that made up the human soul: it had been raised to unnatural pre-eminence at the expense of the passions and above all, the imagination. He felt that in any case these elements now warred against each other leaving man in a state of continual inner conflict.

This rather pessimistic personal philosophy is reflected in this large coloured print by the worm, tinged with red, that winds itself around Adam even at the moment of Creation. Indeed the act of divine Creation is seen here as fraught and difficult, something only groped at awkwardly (and at quite some cost of pain on Adam's part). There is nothing here of that monumental harmony with which Michelangelo had filled the most famous version of this subject on the Sistine ceiling. Blake's print employs very little sense of either space or solidity. Instead he preferred to use strong, dark outlines filled with unnaturalistic colour. The purpose of art, he argued, was to express truth which was hidden behind or beyond the realm of the senses. Realism was therefore to be avoided if art was to fulfil the exalted role he envisaged for it.

Ophelia

1851–52

Sir John Everett Millais

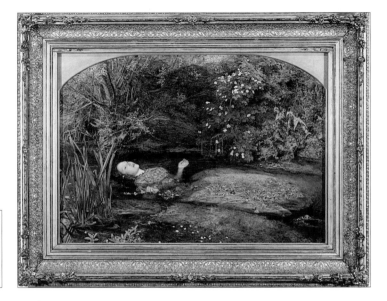

Millais (1829–96) was only twenty-two when he painted his *Ophelia*. He remained faithful to every last detail of the description in Shakespeare's original of the suicide of Hamlet's betrothed: 'There is a willow grows aslant the brook, That shows his hoary leaves in the glassy stream, There with fantastic garlands did she make of crow-flowers, nettles, daisies, and long purples … Her clothes spread wide, And mermaid-like awhile they bore her up, Which time she chanted snatches of old lauds …'

The background was painted from studies made from nature on the banks of the River Ewell in Surrey. Ophelia herself was modelled by Elisabeth Siddal, who was later to marry Millais' friend and fellow-painter, Dante Gabriel Rossetti. She posed in a bath in Millais' studio with lamps lit underneath it in a vain attempt to keep the water warm. Detailed, literal realism was of central importance to Millais: this as well as vigour, sincerity and seriousness were qualities he and a number of other young painters all consciously promoted. In particular they attacked contemporary 'academic' art for its adherence to convention rather than nature. The group was named the Pre-Raphaelite Brotherhood. It was formed in 1848 (an apt year for radical enterprises) by Millais, Holman Hunt, Rossetti and four other young art students. The eminent critic John Ruskin, who described *Ophelia* as 'the loveliest English landscape, haunted by sorrow', was one of the few to support the Brotherhood in the press, although his enthusiasm understandably waned after Millais stole his wife. By the end of the 1850s Millais had ceased painting in a Pre-Raphaelite style and had begun to pursue a very successful commercial career as an artist.

According to Holman Hunt, the brains behind the Pre-Raphaelite Brotherhood, Rossetti (1828–82) never truly belonged to the group as he was not sufficiently fascinated by nature. Nor did his paintings offer any particular social comment, but instead an idealized medieval escapism. Rossetti was always, however, obsessed by female beauty. He had met Elisabeth Siddal in 1850 – she also modelled for Millais's *Ophelia* (page 98) – and eventually married her in 1860. She died in 1862 from laudanum poisoning – hence the white poppy in her lap.

This painting is probably based on drawings he made of her in the year of her death, and is in many ways a memorial to her. It depicts the death of Dante's beloved Beatrice as described in his poem, the *Divine Comedy*. Beatrice/Elisabeth is shown in a state of evident rapture (hence the designation of sanctity in the title). To her left the waning flame of her life is held by a figure Rossetti identified as Love. To her right stands Dante himself. Behind her lie the buildings of the city which sat solitary and silent in mourning at Beatrice's death. This last reference, in fact a quotation from the *Book of Lamentations*, is also inscribed on the frame as is the date of her death – 9th June, 1290. In the roundels sun, stars, moon and earth are represented, corresponding to the last lines of the *Divine Comedy*: 'Love which moves the sun and the other stars.' As if to balance Elisabeth's otherworldly beauty, Rossetti had another mistress called Fanny Cornforth who could crack walnuts with her teeth. He also kept many exotic pets, including a wombat, gazelle and racoon, at his house in Cheyne Walk, Chelsea.

Harmony in Grey and Green: Miss Cicely Alexander

1872–73

James Abbott McNeill Whistler

Cicely Alexander was the daughter of a London banker and art collector who commissioned this portrait. Whistler (1834–1903) himself designed the muslin dress that she wears, and insisted that the fabric should contain no trace of blue. This minor request reveals much of Whistler's intentions – the precise colour relationships within his paintings were as important as any other considerations. The title, with the musical analogy preceding the sitter's name, indicates that his ultimate priority was the abstract organization of his painting. In fact, when asked once about the relation of his pictures to visual reality, Whistler is reported to have replied, 'Nature is catching up.'

This portrait, like much of his work, is indebted to Japanese art – especially wood-block prints which Whistler collected. He parades his debt explicitly by using a Japanese-inspired emblem – the characteristic butterfly – instead of a signature. The combination of large areas of empty space with both delicately painted details, such as the flowers, and a strongly simplified composition, also implicitly reflects Japanese influence. Marrying these exotic conventions to those of traditional portraiture highlighted the artifice inherent in all such systems, something which Whistler vigorously pursued. His provocative adherence to this belief in 'Art for Art's sake' brought him into conflict with the critic John Ruskin. The matter was fought out in an infamous libel case, which Whistler won. However he was only awarded damages of one farthing without legal costs, and the case bankrupted him.

Recumbent figures first appeared in Moore's work in 1929, and they became one of his most enduring themes. This piece, like so many of his other works, incorporates the surrounding space into the carved forms. He sculpted the figure himself out of green Hornton stone outdoors at his home in Kent for the architect Serge Chermayeff's garden. In 1934 Moore (1898–1986) wrote of his sculpture: 'For me a work must first have a vitality of its own. I do not mean a reflection of the vitality of life, of movement, physical action, … but that a work can have in it a pent-up energy, an intense life of its own, independent of the object it may represent. When a work has this powerful vitality we do not connect the word Beauty with it. Beauty … is not the aim of my sculpture.'

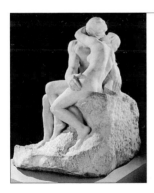

The Kiss was originally envisaged on a much smaller scale, to be part of Rodin's enormous decorative bronze doorway known as the *Gates of Hell*. He soon realized that this tenderly and erotically entwined couple would hardly blend with the tormented figures he had already modelled for the doors and the work became an independent sculpture. It was originally carved in marble by another sculptor working under Rodin's supervision during the 1880s. This is a later version commissioned in 1900. It is the woman who has initiated proceedings. While she forthrightly embraces her lover and has moved her right leg over into his lap, he almost tentatively touches her left hip with his massive hand. In his own tempestuous love affairs, however, it was usually Rodin (1840–1917) who made the running.

The Resurrection, Cookham

1924–26

Sir Stanley Spencer

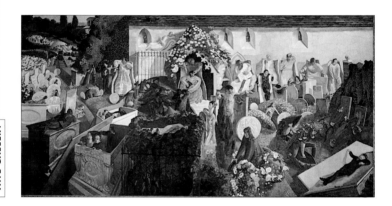

Spencer (1891–1950) first exhibited this enormous painting as the centrepiece of an exhibition of his work in London in 1927. It was immediately recognized as a major achievement and promptly bought by the Tate. It depicts a strangely naive vision of the Resurrection, set in the crumpled space of the churchyard at Cookham, a village on the Thames where Spencer was born and brought up. Despite its monumental dimensions there is something immediately endearing about seeing this cataclysmic event take place in so modest and particular a location. In much the same vein Spencer himself, quoting the seventeenth-century poet and cleric John Donne, described Cookham as 'a holy suburb of heaven'.

God and Christ are seen in the porch in the centre with prophets stretching their limbs on stone seats to the right. To the left, just beneath the porch, a group of black figures are lifting themselves up out of the earth. Their presence lends the image a wider geographical reference, since there were few, if any, Afro-Caribbean people living in the Thames Valley at this point. At the same time Spencer mostly focuses on the familiar. His wife Hilda, for example, appears three times: crossing a stile; smelling a flower; and sleeping on the tomb in the centre. Towards the left, in an especially intimate moment, a woman brushes the dust off the back of a man's jacket – apparently a memory of the artist's mother. There are other light, imaginative touches of comedy: for example, many of the figures are reading the epitaphs on their tombstones. Yet as Spencer wrote of them all, 'No one is in any hurry in this painting ... they resurrect to such a state of joy that they are content.'

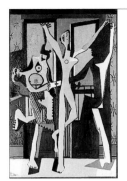

Although he never officially joined the group, Picasso (1881–1973) became an honorary Surrealist on the strength of this work's emotional and formal violence. The painting depicts a very personal tragedy in the form of a Cubist Crucifixion that is coupled with a *danse macabre*. It seems to have begun as an image of dancers at a rehearsal, but in March 1925 Picasso's friend and fellow-painter Ramon Pichot died – he appears as the shadow behind the dancer to the right. There is also a veiled allusion to the suicide of another painter friend, Carlos Casagemas, who killed himself in 1901 for love of the woman named Germaine, who afterwards became Pichot's wife. She becomes the horrific, predatory dancer on the left while the central figure represents Casagemas, partially transformed from dancer to crucified Christ, sent whirling by his former lover into a dance of death.

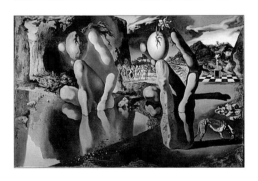

Dali's combination of disturbing subject matter with technical virtuosity is highly compelling. Dali (1904–89) said that the subject had its origin in a comment he overheard when two fishermen were talking about a vain friend of theirs, and one of them commented, 'He has a bulb in his head' – Catalonian slang for saying that someone has a complex about something. In mythology Narcissus fell in love with his own reflection in a pool, eventually being transformed into a flower. He in turn was loved unrequitedly by the nymph Echo, who pined away until only her voice remained. She was only permitted to repeat the last syllables of what she had heard. In the painting Narcissus is glimpsed three times – first on a plinth in the background; second, on the right gazing into the pool; and third, transformed into a flower which bursts from an egg.

Mr and Mrs Clark and Percy

1970–71

David Hockney

This double portrait shows two of the artist's friends – the fashion designer Ossie Clark and his textile designer wife Celia Birtwell – posed semi-formally with their cat Percy in the drawing room of their London home. As with many works by Hockney (b. 1937), this one was painted using a number of photographs of the sitters and their surroundings. The room is sparsely furnished but, as suits his subjects' occupations, everything exudes a sense of taste and style: the lone vase of lilies, the Tiffany lamp, and the print (an early work by Hockney himself) in a gilt frame. It is meticulously, even slickly painted; everything is crisply defined. It is as though the picture as a whole (sitters and surroundings as well as the handling of the paint) were a calmly confident celebration of style.

Double portraits recur often in Hockney's work. Paintings like this one were not commissioned by the sitters, who were asked to pose by the artist himself – presumably something about the subject fascinated him. Hockney has reversed the standard convention of portraiture by showing the man seated with the woman standing. On another level the subject also indirectly addresses questions of connection and separation which touch the artist's own life. Proudly conscious of his working-class roots in northern England, his early fame earned him international notoriety – possibly generating a sense of dislocation that was also compounded by his homosexuality. Behind the trappings of success, Hockney himself seems to be peculiarly aware of a sense of isolation.

When Bacon (1909–92) exhibited this triptych in London in 1944 it caused something of a sensation. He had shown nothing since 1937 and indeed he later said he considered that only with this work did his serious painting begin. T.S. Eliot, a poet whom Bacon read and admired, wrote: 'Human kind cannot bear very much reality.' He was probably right. Bacon on the other hand seems to have dedicated himself as an artist to exposing those sides of ourselves which we would prefer to forget or ignore (if we are aware of them at all). This, arguably, is why his paintings are so brutally and painfully violent. He chose to confront our inability to tolerate our own ugliness – his paintings' violence was, in part, necessary if obstacles to the truth were to be removed. One of his preferred tactics in this quest was to depict figures that mingle human with animal traits. Here the three traditional figures mourning at the foot of the Cross (the Virgin Mary, Mary Magdalene and St. John) have been transformed into blind, limbless animals. There is of course no Cross here in the painting, and therefore no hope of redemption or eternal life. It is as if these creatures, aware of the hopelessness of their destiny, can only respond with an agonized scream. Bacon also once described these figures as 'Eumenides', that is the ferocious instruments of divine vengeance in Greek mythology. In so doing he was hinting at another reversal of the traditional meaning of the Crucifixion as the vessel of God's forgiveness.

✪ The Snail

1953

Henri Matisse

Matisse (1869–1954) began his life as a painter in bed, at the age of twenty when his mother gave him a box of paints while he was convalescing from appendicitis. In a curiously neat way, Matisse also ended his long career there, as an eighty-year-old invalid, drawing portraits of his grandchildren on the ceiling above his bed with a pen attached to a long bamboo pole; or cutting rarefied, abstracted shapes out of hand-coloured sheets of paper for his final, monumental and triumphant collages. These shapes were then pinned in place by assistants working under his direction, to be stuck down later. For Matisse this procedure proved a liberation. It was the final resolution to a dilemma that had occupied him from the very beginning. That was, should he give priority to colour or to line in his paintings? The two are distinct, but using this method Matisse could 'draw' with his scissors directly into the coloured paper, so the two became one. *The Snail* is one of the largest cutouts Matisse made. At first it seems almost abstract. However the spiral of coloured shapes represents the shell, resting on a rectangular blue body. In fact Matisse only took up the scissors once he had drawn and held a real snail time and time again. This interlocking fan of complementary colour, both organic and ordered, was the result.

In 1958 Rothko (1903–70) was commissioned to provide a series of murals to decorate a room in the newly finished Seagram Building in New York. In many ways the commission was an ideal one, for Rothko was to have complete control over the way the paintings were hung. But for reasons which are still not entirely clear he withdrew from the commission in 1960, having already completed numerous canvases. In part, it seems that Rothko was unhappy with the idea that the room would be used as a restaurant. The paintings he produced, 'intimate and intense' as he described them, do seem inappropriate for such a setting. In 1965 the then Director of the Tate offered to hang the works in the Gallery. Rothko agreed to donate nine of them. They are usually exhibited apart and with minimal artificial light, according to the artist's wishes.

Unlike Pollock and other American Abstract Expressionists, Rothko relied on colour rather than gesture to generate meaning. The surfaces have little textural interest, but the finely painted layers of thin pigment seem to radiate a subdued light. The massive blocks of colour shimmer darkly in a state of fine tension between static symmetry and minute movement. Their pulse is slow and subtle, their edges blurred and overlapped. Despite their size they seem to float immaterially. Surrounded by these sombre, brooding forms the viewer must wait for their colours and rhythms to work on the sensibility. Rothko himself said that he was in favour of 'the simple expression of complex thought'. Open or closed, advancing or receding, it is up to the viewer to decide what these monolithic blocks might possibly signify.

Snow Storm:
Steam Boat off a Harbour's Mouth

1842

Joseph Mallord William Turner

Turner (1775–1851) claimed that he had had himself tied to the mast of a ship and taken out into a storm at sea so as to be able to witness at first hand Nature's raging, destructive powers. It is a story oddly reminiscent of the myth of Odysseus who lashed himself to the mast of his boat in order to hear the intoxicating but deadly song of the Sirens. Whether it is true or not, it portrays Turner as the epitome of the Romantic artist – one willing to immerse himself fully in terrifying, natural forces. These Turner translates on to canvas in a welter of vigorous, free brushstrokes arranged in a spiralling configuration to denote the whirling cascades of sea, smoke and snow. In the midst of this vortex of uncontrolled energies the mast and paddles of the steam boat can just be glimpsed.

Turner began his career as a topographical artist, painting and engraving accurate views of specific places. This kind of work had a large market. It brought him financial security and the freedom to pursue innovative experiments in works such as this which were less likely to find buyers. Turner's investigations initially concerned the study of light itself, disembodied or distinct from the objects or views which it revealed to the eye. These in turn led him to explore the abstract potential of colour and brushwork, irrespective of subject matter. As a result he discovered that a painting could function as an equivalent of the subject it sought to describe rather than an exact imitation of it.

Begun 1078

The Tower of London has served as a fortress, a garrison, a royal residence and a prison. The White Tower, distinctive with its round Norman windows and arches, is the oldest part of the whole, started by William the Conqueror and finished by his son. In the thirteenth century it was Henry III who turned the castle into a massive fortress complex. As well as the Crown Jewels the Tower also houses The Armouries, a unique collection of European and Oriental arms and armour. The complex is guarded by a garrison of 'Beefeaters' or Yeoman Warders, whose costume is thought to date from the time of Henry VIII or Edward VI. Many figures central to British history were imprisoned, tortured or executed here. They include Henry VI; 'the little princes in the tower', Edward V and his brother; Anne Boleyn; Sir Thomas More; Catherine Howard; Lady Jane Grey, Lord Dudley; Archbishop Cranmer; Sir Thomas Wyatt, Sir Walter Raleigh and Guy Fawkes. The Tower also used to house the royal menagerie, the core of the present collection at London Zoo. This is probably how the ravens found their home here.

Address
Tower Hill, London
EC3N 4AB
✆ 071 709 0765

Map reference

How to get there
Tower Hill underground.
Buses: 42, 78.

Opening times
1 March to 31 Oct: Mon to Sat, 9–6, Sun, 10–6 (last tickets at 5); 1 Nov to 28 Feb: Mon to Sat, 9–5, Sun 10–5 (last tickets at 4). Closed on 24, 25 & 26 Dec, 1 Jan.

Entrance fee
£7.95. Discounts for children, students and pensioners and groups.

The Crown Jewels

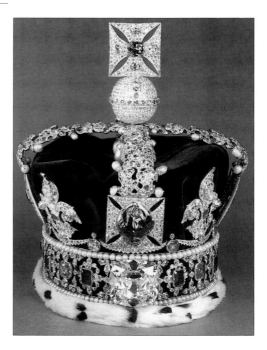

Recently the rooms in which the jewels are shown have been reorganized and extensively redecorated. They are housed in the Waterloo Block to the north of the White Tower. After the execution of Charles I many of the ancient jewels, crowns and other regalia were sold and dispersed. The present collection dates only from the Restoration, when the jewels were first publicly exhibited for a fee. Since then they have been variously reset. Of particular note among them are: the Crown of Queen Elizabeth, the Queen Mother (1937), which is set with the famous Indian diamond, the *Koh-i-noor*, or Mountain of Light, whose history stretches back to the thirteenth century, and St. Edward's Crown (1661), used for the coronation of the sovereign. This weighs five pounds and may have been made from the gold of the Saxon diadem, said to have been the crown of Edward the Confessor, which was broken up during the Commonwealth. The Imperial State Crown of Elizabeth II (1953), which is worn for the return from Westminster Abbey and on other state occasions, is also impressive. It was originally made for Queen Victoria, and among its jewels is the large uncut ruby given to the Black Prince by Pedro the Cruel in 1367 and worn by Henry V at Agincourt. The Sceptre with the Cross (1661) was set this century with the grandest of the 'Stars of Africa', the largest cut diamond in the world weighing 530 carats.

The Victoria and Albert Museum (known as the V&A) is probably the greatest decorative arts museum in the world. It began as the Museum of Manufactures in 1852, established at the instigation of Prince Albert and the civil servant Henry Cole. The museum was intended to follow up the success of the Great Exhibition of 1851, also their initiative, by forming a permanent public collection of superlative examples of the fine and applied arts – not just for public interest but also as a spur to British designers and manufacturers. In 1857 it moved from its original premises in Pall Mall to its present site, and became part of the South Kensington Museum. A new building was erected in the 1870s, designed by Aston Webb. In her last public ceremony in 1899, Queen Victoria changed its name to the present one.

The collection is enormous, taking up an area of roughly thirteen acres. The most recent addition of space, the Henry Cole Wing, opened in 1983. This annexe, on eight floors, houses a collection of approximately one million items – prints, drawings, photographs, painted miniatures, and an entire floor devoted to the paintings of John Constable, as well as a number of sculptures by Rodin. In the main building the various collections are divided into Primary Galleries, which are aimed at the general visitor, and Study Collections, of particular (though by no means exclusive) interest to specialists. The Primary Galleries occupy the ground and first floors. Among these are displays of Indian, Chinese, Islamic and Japanese arts and crafts, as well as rooms devoted to European Medieval and Renaissance sculpture. Displays on the first floor include jewellery, interior design, ceramics, glass, metalwork and textiles. The Study Collections are housed on the upper floors.

Address
Cromwell Road, South Kensington, London
SW7 2RL
✆ 071 938 8500 . Recorded information on 071 938 8441 or 071 938 8349.

Map reference

How to get there
South Kensington underground. Buses: 14, 30, 74, C1.

Opening times
Tues to Sun, 10–5.50; Mon 12–5.30: Sat, 2.30–5.50; closed on 24, 25 & 26 Dec, Good Friday, May Bank Holiday.

Entrance fee
Admission is free though donations are expected.

Tours
Lectures, free guided tours, films (Mon to Fri).

✪ Peter and John
Healing the Lame Man at the Temple

1515–16

Raphael (Raffaello Sanzio)

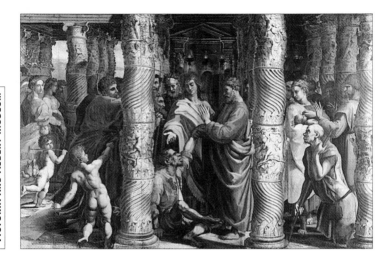

The Victoria and Albert Museum houses on the ground floor the surviving seven out of ten designs (called 'cartoons') made by Raphael (1483–1520) for tapestries to hang in the Sistine Chapel, beneath Michelangelo's ceiling. They were commissioned by Pope Leo x as a celebration of papal power at a time when the authority of the Church was under threat from Luther and the German states. They were later bought by Charles I in 1623 through the offices of Rubens. Wren built a room for their display at Hampton Court in 1699; Queen Victoria then lent them to the South Kensington (now the V&A) Museum in 1861. Because of the type of loom used to make the tapestries Raphael was obliged to make his designs in reverse, rather like a photographic negative. By way of comparison a tapestry made later in the seventeenth century from one of the other designs hangs in the same room.

The subject of Peter and John healing the lame man at Solomon's temple in Jerusalem is taken from the book of Acts in the Bible. Raphael shows the moment when the lame man, with an expression of wonder on his face, is about to stand. The energetic, sculpted figures on the pillars contain a veiled allusion to the fact that in a moment he is going to be leaping to his feet. Crowds have gathered to watch the miracle. On the far right a temple guard mimics Peter's gesture, a deliberate juxtaposition of spiritual and temporal authority that would have had particular political significance for contemporary audiences. The cartoons arguably constitute the greatest example of Italian High Renaissance art in Britain, exceptional for their grandeur, monumentality and intellectual clarity.

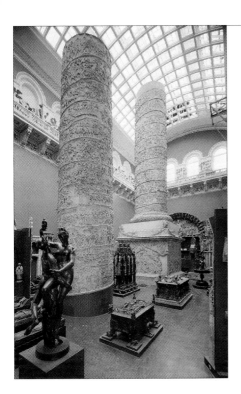

These two great rooms, recently restored to their 1873 appearance, lurk on the eastern side of the museum – massive, grandiose testaments to Victorian cultural imperialism. The first, called The Victorian Vista, contains casts taken from numerous masterpieces of European architecture – for example the facade of the Cathedral of Santiago de Compostela in Spain and Trajan's Column in Rome. Note also the cast of the less well-known carved, wooden decoration taken from a church in Urnes in western Norway. The intricate, interlaced pattern represents the final, most delicate and refined flowering of Viking ornament. The second room, The Italian Vista, contains casts of the greatest masterpieces of Italian Renaissance sculpture by Donatello, Ghiberti, Michelangelo and others. These were taken primarily for the instruction of art students. Nineteenth-century art education was based on the imitation and emulation of the past, and specifically on a programme of instruction that had been developed from those of the very first academies established in Renaissance Italy. Drawing – first from sculptures or plaster casts, and later from the model – was given highest priority. Great emphasis was placed on the correct placement of the contour or outline and the corresponding skill of modelling, or gradual shading from dark to light with pencil or charcoal to describe volume. Students were expected to be able to perform both these skills with precise anatomical correctness. Only after a student's ability in drawing was deemed satisfactory was he or she then allowed to handle colour. It was against this kind of academic style that many 'modern' artists were to rebel.

A Group of Chinese Musicians

c. 1755

Chelsea China Works

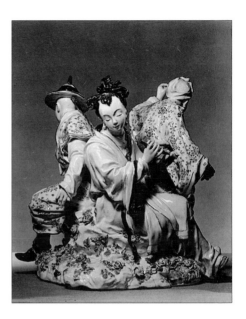

This superb example of English *chinoiserie* is part of the museum's extensive ceramics collection. Chinese artefacts have held a fascination for European markets for centuries, associated as they are in the Western mind with luxury, rarity and exoticism. The term *chinoiserie* however refers to European imitations of Chinese styles in the arts and crafts that reflect imaginary and poetic ideas of China that often had little or no connection with the real thing. For example, in the seventeenth century textiles were designed by Indian craftsmen specifically catering to the English fashion for things Chinese. These designs were then exported to China, copied by Chinese weavers and sold in European markets.

The figures of these four Chinese musicians were probably taken from engravings of paintings by French artists like Boucher or Watteau, or copied from other European porcelain pieces. The piece was made in Chelsea in south-west London. The Chelsea China Works was founded *c.* 1745 by Nicholas Sprimont (1716–71), a French Huguenot from Liège. It was a small enterprise, with no more than one hundred employees at any one time, which catered to a luxury market. The Chelsea factory ceased operation in 1770. It competed with other firms based in Bow (in east London), Staffordshire, Derby, Worcester and others. Each kept the mixes of their colours and porcelain closely guarded secrets. This piece was designed and cast as a whole (unusual for the time). It is slightly damaged – the girl with a tambourine also holds a broken bell. Nevertheless, however tenuous a link they may have had with real Chinese musicians, the figures with their swirling draperies are full of charming movement.

Salisbury Cathedral from the Bishop's Grounds

1823

John Constable

The Constable Collection, housed in the Henry Cole Wing, contains finished works as well as hundreds of studies and sketches. Most were donated in 1888 by the artist's daughter Isabel. *Salisbury Cathedral from the Bishop's Grounds* is unusual in Constable's oeuvre in that it was specifically commissioned – by his friend John Fisher, Bishop of Salisbury. In his letters Constable (1776–1837) admitted that he disliked painting architectural subjects, although he did make this painting the principal entry to the Royal Academy exhibition of 1823. That year he wrote of this work to Fisher's nephew, 'It was the most difficult subject in landscape that I ever had upon my easel. I have not flinched at the work, of the windows, buttresses, etc, etc, but I have as usual made my escape in the evanescence of the chiaroscuro.' By chiaroscuro Constable meant the dramatic and varied effects of light and shade on the landscape. To this end he placed an unprecedented emphasis on the representation of the sky. As he wrote in a letter in 1821, 'That Landscape painter who does not make his skies a very material part of his composition, neglects to avail himself of one of his greatest aids … [it is] the key note, the Standard of Scale and the Chief Organ of Sentiment.' Bishop Fisher however was unhappy with the dark cloud hovering in the right corner and asked for a clear blue sky. Constable painted him another version. The Bishop and his wife appear in the bottom left pointing towards the cathedral which is framed by a Gothic arch formed by two great trees. It is as if the architecture were mimicking forms already inherent in nature.

Address

Hertford House, Manchester
Square, London W1M 6BN

 071 935 0687

Map reference

㊷

How to get there

Bond Street underground.
Buses: 1, 2, 2b, 6, 7, 8, 12,
13, 15, 16a, 30, 73, 74, 88,
113, 137, 159, 500.

Opening times

Mon to Sat, 10–5; Sun, 2–5;
closed on 24, 25 & 26, Dec,
1 Jan, Good Friday, May
Bank Holiday.

Entrance fee

Admission is free.

Tours

Lunchtime lectures; guided
tours need to be arranged
beforehand.

Hertford House, built by the Fourth Duke of Manchester in 1776 and situated in a quiet square north of Oxford Street, is the permanent home of the Wallace Collection, one of the most varied private collections ever assembled. This comprises, in addition to a number of superb European old master paintings (in particular works of the French eighteenth century), excellent collections of arms and armour, furniture and porcelain, particularly Sèvres. The collection was formed in the main by Richard Seymour-Conway, Fourth Marquess of Hertford (1800–70). He died unmarried and bequeathed it to his illegitimate son Sir Richard Wallace (1818–90), who installed it in Hertford House. Incidentally, as a rather marvellous gesture, Wallace also paid for a number of public drinking fountains in the Latin Quarter in Paris.

The family were noted for their flamboyance and style; the Third Marquess, for example, appears as the dissolute Lord Stayne in Thackeray's novel *Vanity Fair*. In 1897 Richard Wallace's widow, Lady Wallace, left the collection to the nation on condition that nothing was either added, sold or loaned. As a result the house, opened to the public in 1900, retains much of its original atmosphere. Despite both its high quality and central location, the collection is rarely (if ever) crowded. In addition to the paintings described in the following pages the visitor might want to note the works here by Boucher, Watteau, Velázquez, Murillo, Titian, Reynolds and Rembrandt.

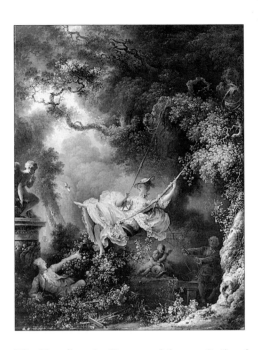

The French artist Fragonard (1732–1806) painted exclusively for the Ancien Régime – he counted both Madame de Pompadour and Madame du Barry, mistresses of Louis xv, amongst his patrons. His first major painting was bought by the Crown in 1765 and thereafter he was able to find plenty of commissions from private patrons, both royal and aristocratic. *The Swing* was devised and commissioned by a courtier, who is shown looking up at his mistress who is pushed on her swing by an older man (the courtier had originally specified a bishop). The work is undeniably erotic; the line of the man's arm leads directly to the woman's skirt, drawing attention to the large amount of leg she is displaying. A statue of Cupid looks on, while two winged *putti* frolic in the background.

As early as 1699 Louis xiv had signalled a change in royal taste and patronage by calling for paintings that were more light-hearted than those produced by artists who were members of the Academy. Initially this demand was met by court painters such as Chardin and Boucher (to each of whom in turn Fragonard served a short apprenticeship). Fragonard was to some extent influenced by both but made his own personal contribution to what came to be called French Rococo style. His paintings exude an informal elegance, appealing directly to the senses rather than the intellect. In subject as well as technique they celebrate spontaneity and freedom from Academic restraint. For some, of course, they seemed to typify the indulgence and frivolity of a degenerate upper class.

Dance to the Music of Time

c. 1639–40

Nicolas Poussin

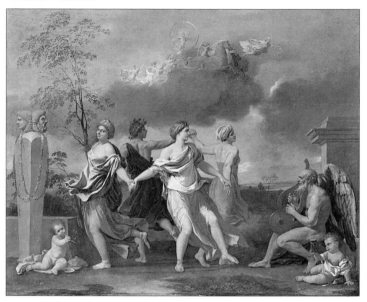

The French painter Poussin (1594–1665) first went to Rome in 1624 and remained there for most of his life. In 1628 his first public commission, an altarpiece for St. Peter's, met with disapproval and thereafter he worked only for private patrons. These were mostly a group of learned scholars and collectors who shared Poussin's own intellectual interests. For such men he painted mythological rather than religious subjects in an increasingly unfashionable but restrained classical style. This painting was made for Giulio Rospigliosi, later to become Pope Clement IX, who probably drew up the scheme. On the left a cherub blows a bubble (symbol of life's transience) beneath a statue of Janus, who is shown with the double face of youth and age. On the other side another cherub stares at an hour-glass, seated at the feet of Time (a winged old man holding a lyre). In the sky the sun god Phoebus rides his chariot preceded by Aurora, goddess of the dawn. The dancers represent different facets of human life. From left to right they are Pleasure, Poverty, Riches and Work. But their dance, cordoned on all sides by figures symbolizing the various cycles of age and time, is seen as subject to strict limitations. The overall implication is the vanity of human achievement.

As in most of Poussin's painting, drawing not colour is predominant. Colour itself is organized, not according to any descriptive principle, but artificially – to give clarity to the idea embodied by the figures. It is deployed in clear blocks, and often in dissonant pairings to arrest the attention. Poussin's influence on French painting was enormous; the Académie des Beaux-Arts based many of its precepts on his theories.

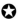
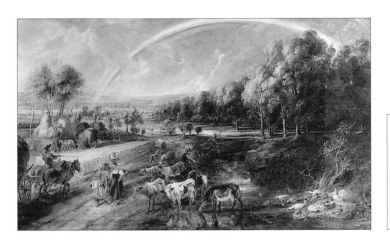

Rubens (1577–1640) was something of a polymath: he worked both as an artist and as a high-ranking diplomat for the Hapsburg court. Born in Antwerp he received a full, Classical education before training as a painter. In the latter he was phenomenally successful, producing sumptuous narrative and mythological works for his aristocratic and royal patrons and painting theatrical religious pictures for the Catholic Church. So great was the demand for his work that Rubens had to employ an army of assistants to satisfy his numerous patrons. He was able to amass a substantial fortune, and retired to a country estate just to the south of Antwerp, the Château de Steen, which he bought in 1635. Here he began to paint landscapes – not to sell but purely for his own pleasure – of the surrounding countryside. No doubt part of his reason for doing so was because he now owned land. But Rubens had also recently married the sixteen-year-old Hélène Fourment, four years after the death of his first wife. Something of his own personal happiness seems to infuse these views of nature. Here a great rainbow heralds the re-emergence of the sun, as it begins to sweep away the storm clouds in the top right corner. Beneath its warm light we are offered a view of all the rich fullness of nature. The dramatically plunging diagonal perspective draws the spectator immediately into Rubens's harmonious and benevolent vision. This work is probably a pendant to the *Landscape with a view of Het Steen* in the National Gallery.

The Laughing Cavalier

1624

Frans Hals

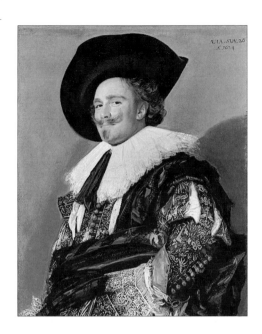

Strictly speaking, the sitter in this portrait is neither laughing nor a cavalier. His identity is uncertain, although he is known to have been twenty-six years old. Hals (*c.* 1581/5–1666) lived and worked in Haarlem, an important port in the newly formed Dutch Republic. In his early twenties, Holland and a number of other northern Dutch provinces had revolted against their Spanish rulers, being granted tacit recognition by 1609. Since the aristocratic classes had departed with the Spanish and the Protestant Church forbade the making of images, artistic patronage (as well as political power) passed into the hands of the bankers, merchants and manufacturers. Painting therefore became the property of the middle classes. The Dutch people's newly won independence also stimulated a deeply felt national pride. As a result the paintings the merchant classes wanted were those which reflected themselves (hence the popularity of portraiture), their possessions (still life), and their territory (landscape).

Demand for art ran very high throughout the seventeenth century and artists began to specialize in particular genres. Hals's niche lay in portraiture. This work was made when Hals was at the height of his popularity. The competitive Dutch art market valued novelty and Hals's innovations proved (for a while at least) especially attractive. The apparent spontaneity of his painting style, with its abbreviated, almost jagged brushwork (most apparent in the treatment of drapery), won him many commissions. Later his work went out of fashion as patrons looked for slicker, more aristocratic portrayals of themselves. The portrait's nickname originated in the nineteenth century, when Hals's reputation underwent a revival.

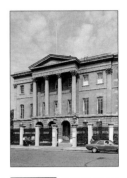

Apsley House used to be known, incomparably, as 'No. 1, London'. It was the home of Arthur Wellesley, First Duke of Wellington (1769–1852), victor of the Battle of Waterloo and Prime Minister from 1828 to 1830. The house was offered to the nation in 1952 by the Seventh Duke and is now administered by the Victoria and Albert Museum. The collection here is especially important for a number of fine paintings from the Spanish Royal Collection, including works by Correggio, Rubens, Murillo and Velázquez. These were captured from the French army, who had previously plundered them, at the Battle of Vittoria in 1813, and presented to the Duke by Ferdinand VII of Spain. The Duke himself built up an impressive collection of Dutch paintings.

The house was built between 1771 and 1778 by Robert Adam for Baron Apsley. It was then sold in 1807 to the Duke of Wellington's elder brother for £16,000. He subsequently sold it to the Iron Duke ten years later for £42,000 (presumably with no love lost). Wellington added the Waterloo Gallery in 1828, where he held annual dinners for his old comrades-in-arms from the battle which had defeated Napoleon. The magnificent silver which used to be on show here has been moved to the Dining Room, and the Gallery now houses many paintings from the Duke's collection, including his favourite *Agony in the Garden* by Correggio which he used to inspect every morning; only the Duke was allowed to dust its glass. Other items of particular interest in the house include a set of Sèvres porcelain given by Napoleon to the Empress Josephine as a divorce present which she rejected, and which was later given to the Duke by Louis XVIII on his Restoration in 1818. The immense marble statue of Napoleon by Canova was another gift, from the British Government.

Address
Apsley House, 149 Piccadilly,
W1V 9FA
 071 499 5676

Map reference
㊸

How to get there
Hyde Park Corner underground. Buses: 9, 10, 14, 19, 22, 52, 73, 74, 74b, 137.

Opening times
The house is currently closed for restoration. Due to reopen in 1995. Tue to Sun, 11–5; closed on Mon (except Bank Holidays), 24, 25 & 26 Dec, 1 Jan, Good Friday and May Bank Holiday.

Entrance fee
£2.50. Discounts for students and pensioners.

The Water Seller

c. 1620

Diego Velázquez

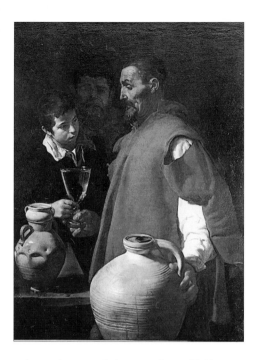

The Water Seller is an early work, one of the very finest Velázquez (1599–1660) painted while still living in his native Seville before he moved to Madrid in 1623 to become court painter to Philip IV. In type it is known as a *bodegone* (Spanish for workshop). This was a genre of painting that was very popular in Spain at the time, which incorporated figures with still life objects, all by definition of a lowly, ordinary status. Velázquez treated the genre with unprecedented gravity, subjecting each figure and object to the most detailed and precise description in terms both of light and of texture. In this he was probably influenced by the paintings of the Italian artist Caravaggio, whose pictures, decidedly realist in style, were being imported into Spain from Naples.

Here the substances of flesh, cloth, glazed and unglazed earthenware are each clearly differentiated. Two passages in particular can be seen as deliberately orchestrated *tours de force* of the painterly description of the action of light: the drop of water running down the side of the pot in the foreground, and the fig that has been dropped into the glass of water to keep the taste sweet. Velázquez rarely made drawings before taking brush to canvas, and changes that he made to the collar, sleeves and hand of the main figure are now beginning to show through. Later in his career, after his appointment to Philip IV, Velázquez ceased to devote himself so much to textural differences to concentrate almost exclusively on the description of light. In this his concerns are comparable with those of some of his most illustrious artistic contemporaries – Claude, Vermeer and Rembrandt.

Begun 1245

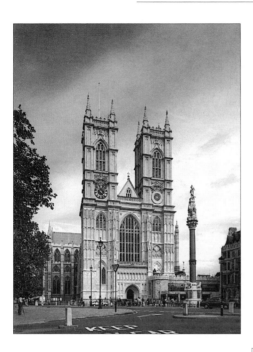

A Benedictine monastery used to stand on the site of the present Abbey. However, in the eleventh century it was enlarged on a massive scale by Edward the Confessor, when the main royal residence moved from Winchester to Westminster. The Abbey has remained intricately bound up with the monarchy, and hence British history, ever since. In 1245 Henry III rebuilt the Confessor's Romanesque abbey in the French Gothic style, and this is the structure that still stands today. Henry spent enormous amounts of money on it – one tenth of the kingdom's wealth – and further riches were spent on adorning the Abbey by subsequent kings, not least by Henry VII who built a chapel to the east of the apse (1503–12) where his and many other royal tombs now lie. This is probably the most lavishly decorated part of the whole, especially noteworthy for the intricate fan vaulting on the ceiling. As well as acting as a royal mausoleum the Abbey also provides the stage for the Coronation. With only three exceptions, every monarch since William the Conqueror (1066) has been crowned here.

Address
Broad Sanctuary, London SW1
 071 222 7110

Map reference
(44)

How to get there
Westminster or St James's underground. Buses: 3, 11, 12, 24, 53, 77a.

Opening times
The Nave: 7–6; Royal Chapels: Mon to Fri, 9–4.45 (last admission at 4); Sat, 9–2, 3.45-5. Closed Sun, 25 Dec and Good Friday.

Entrance fee
£4.00 for Royal Chapels. Discounts for children, students and pensioners.

Begun 1895

Address
Between Victoria Street and
Francis Street, London sw1
✆ 071 834 7452
(administration) or 071 828
4732 (times of mass and
confession).

Map reference
⑤

How to get there
Victoria underground.
Buses: 3, 11, 12, 24, 29, 53,
88, 159.

Opening times
Daily, 6.45–8 (the Cathedral
closes at 7 from Nov to
March). Tower open daily
9.45-5 March-Oct; Nov-Feb
weekends only.

Following the granting of a degree of political freedom by Act of Parliament in 1829, the Catholic community in England was permitted to play a much larger role in public life. One result of this was the decision to build a cathedral in London. When enough funds and a suitable site became available the foundation stone was laid in 1895. It was Cardinal Vaughan, the Archbishop of Westminster, who rejected a number of designs for a Gothic structure – partly because it would have been too expensive and partly because it might have been overshadowed by the authentic Gothic architecture of nearby Westminster Abbey. The architect, J.F. Bentley, accordingly designed a building closely related to the Romanesque Duomo in Pisa and the Byzantine St. Mark's in Venice. The Italian Romanesque style is rare in England though it has an illustrious pedigree elsewhere in Europe. The interior is lavishly decorated with marble and mosaic. One highly unusual touch was to have galleries extending across the transepts lending emphasis to the high altar.

The author and publishers would like to thank the following individuals, museums, galleries and photographic archives for their kind permission to reproduce the following illustrations:

Museum of London: 6.

The Board of Trustees of the Victoria & Albert Museum (photo Bridgeman Art Library) 7, 12b.

The Board of Trustees of the Victoria & Albert Museum: 112, 113, 114, 115, 122.

National Gallery: 8, 58, 59, 60a&b, 61, 62, 63, 64, 65, 66, 67, 68, 69, 70, 71, 72, 73a&b.

Crown Copyright. Historic Royal Palaces: 9, 110.

Guildhall Library (photo Bridgeman Art Library): 10.

Private Collections (photo Bridgeman Art Library): 11a, 13.

Angelo Hornak: 11b.

National Portrait Gallery: 12a, 78a&b, 79.

A.F.Kersting: 14, 18, 19, 20, 21, 25, 26, 28, 35, 40, 41, 43, 44, 51, 52, 55, 56, 76, 80, 83, 85, 87, 88, 89, 93a&b, 109, 111, 123, 124.

Tate Gallery: 15a, b&c, 16a(© ADAGP, Paris and DACS, London 1995), 16b, 101a(© The Henry Moore Foundation), 101b, 102, 103a(© DACS 1995), 103b(© DEMART PRO ARTE BV/DACS 1995), 104(© David Hockney, 1971),105, 106(© Succession H.Matisse/DACS 1995), 107 (© ARS, N.Y. and DACS, London 1995), 108.

British Museum: 22, 24.

British Library: 23.

Raquel Dias: 27, 33, 34, 38, 39, 46, 47, 53, 57, 74, 77, 81, 82, 90, 92, 94, 116.

Courtauld Institute Galleries: 29, 30, 31, 32.

The Trustees of Dulwich Picture Gallery: 36, 37.

The Royal Collection. © 1995 Her Majesty Queen Elizabeth II: 42.

Imperial War Museum: 45.

Kenwood, The Iveagh Bequest (English Heritage Photographic Library): 48, 49, 50.

Royal Botanic Gardens, Kew: 54.

National Maritime Museum: 76.

Ranger's House (English Heritage Photographic Library): 84.

Royal Academy of Arts: 86.

The Trustees of Sir John Soane's Museum: 91.

The Trustees of The Wallace Collection: 117, 118, 119, 120.

Index of Artists, Sculptors and Architects
Figures in bold refer to main entries

A note on the itineraries

The following itineraries are designed for those with a week to spend in London. They have been arranged as far as possible in order of importance, although the suggested combinations for each day have also been governed by practical concerns such as location and ease of travel between the attractions. It should be possible to view everything suggested on each day's itinerary, but visitors may well choose to proceed at a more leisurely pace and concentrate on one or two locations and exclude others. Those with limited time should focus on the starred items. Works of art are listed in the order that they are most likely to be seen within each museum or gallery. The numbers in circles beside each location are map references.

The Marianne North Gallery ㉓ (p. 54), Chiswick House ⑥ (p.26), Syon House ㊳ (p.93), Osterley Park House ㉘ (p.80), Ham House ⑭ (p.40), and Hampton Court ⑮ (p.41), are all a reasonable distance to the west of central London, but because they are a little way out of the centre and it takes slightly longer to travel to see them, they have not been listed with the other attractions. Half a day should be allowed for each or possibly for either of the following combinations: Syon House and Ham House; Chiswick House and The Marianne North Gallery. The others, Osterley Park House and Hampton Court, need half a day each. The following have restricted opening times and so have not been included on the main itineraries:

Buckingham Palace ⑤ (p.25) – August and September only. (Slot into Day 4 Morning if possible.) Spencer House ㊲ (p.92)– Sundays only. (Slot into Day 5 Morning if possible.)

The entry fees and opening times are correct at the time of publication, although they may be liable to change without notice.

DAY 1 MORNING

✪ **NATIONAL GALLERY** ㉕ (p.56)

The Wilton Diptych
French School (p.58)
The Baptism of Christ
Piero della Francesca (p.59)
Madonna of the Meadow
Giovanni Bellini (p.60)
Mythological Subject (Death of Procris?)
Piero di Cosimo (p.60)
✪ **The Arnolfini Marriage**
Jan van Eyck (p.61)
✪ **Cartoon: The Virgin and Child with St. Anne and St. John the Baptist**
Leonardo da Vinci (p.62)
Bacchus and Ariadne
Titian (p.63)
Allegory of Love
Agnolo Bronzino (p.64)

The Ambassadors
Hans Holbein the Younger (p.65)
Equestrian Portrait of Charles I
Anthony van Dyck (p.66)
Mr. and Mrs. Andrews
Thomas Gainsborough (p.67)
Experiment with an Air Pump
Joseph Wright of Derby (p.68)
The Hay Wain
John Constable (p.69)
Rain, Steam and Speed – The Great Western Railway
JMW Turner (p.70)
The Rokeby Venus
Diego Velázquez (p.71)
Umbrellas
Pierre-Auguste Renoir (p.72)
Une Baignade, Asnières
Georges Seurat (p.73)
Large Bathers
Paul Cézanne (p.73)

✪ **BANQUETING HOUSE, WHITEHALL** ②
(p.19)